BY THE SAME AUTHOR

Raven's L'il Critters

*If Your Possum Go Daylight
and Other Twisted Verses
for Children to Share
with their Parents*
(text by Randy Lofficier)

by
Raven OKeefe

A Black Coat Press Book

Copyright © 2012 by Raven OKeefe.

Visit the artist's websites:
http://www.ravenokeefe.com
Horse portraits:
http://www.ravenshorses.com
Faithful friends portraits:
http://www.faithfulfriendsportraits.com
L'il Critters:
http://ravenslilcritters.com
Wool Sculpture:
http://www.woolsculpture.com
Wildlife & Fine Art:
http://www.artbyraven.com
Border Collies Art:
http://www.bcstyleyes.com
http://www.canismajorart.com

To contact Raven OKeefe:
e-mail: portraits@ravenokeefe.com
post: 39562 Highway 226, Scio, OR 97374.

My great thanks to Randy and Jean-Marc for making this book possible! And to all of my many, many wonderful clients who have commissioned pet portraits, I've been honored to create each one, and if yours isn't included, it's due only to lack of space, not absence of love.

Raven

ISBN 978-1-61227-139-2. First Printing September 2012. Published by Black Coat Press, an imprint of Hollywood Comics.com, LLC, P.O. Box 17270, Encino, CA 91416. All rights reserved. Except for review purposes, no part of this book may be reproduced or transmitted in any form or by any means, electronic or mechanical, including photocopying, recording, or by any information storage and retrieval system, without permission in writing from the artist or the publisher. Printed in the United States of America.

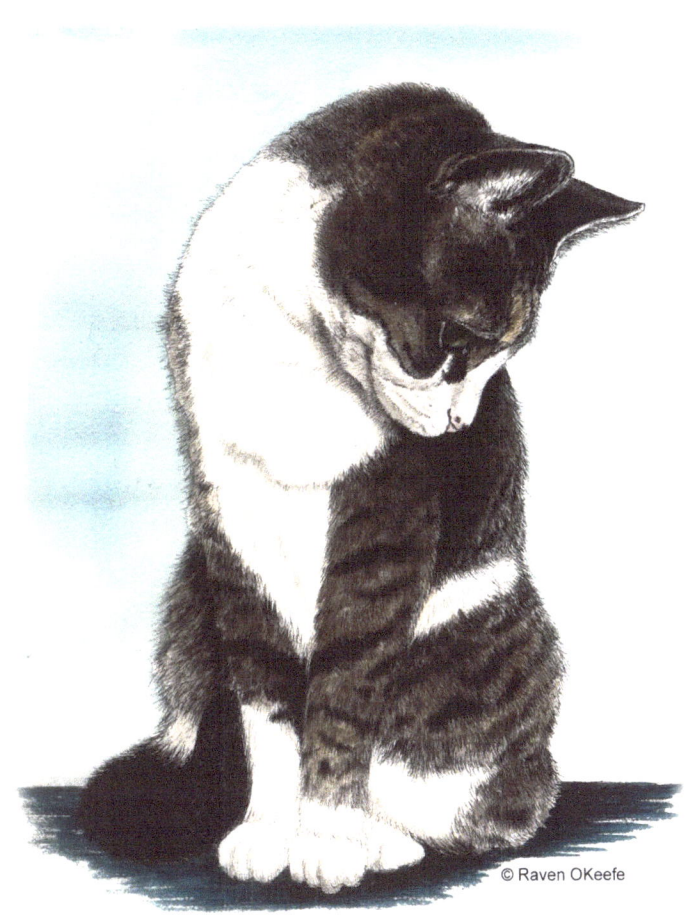

Arlo

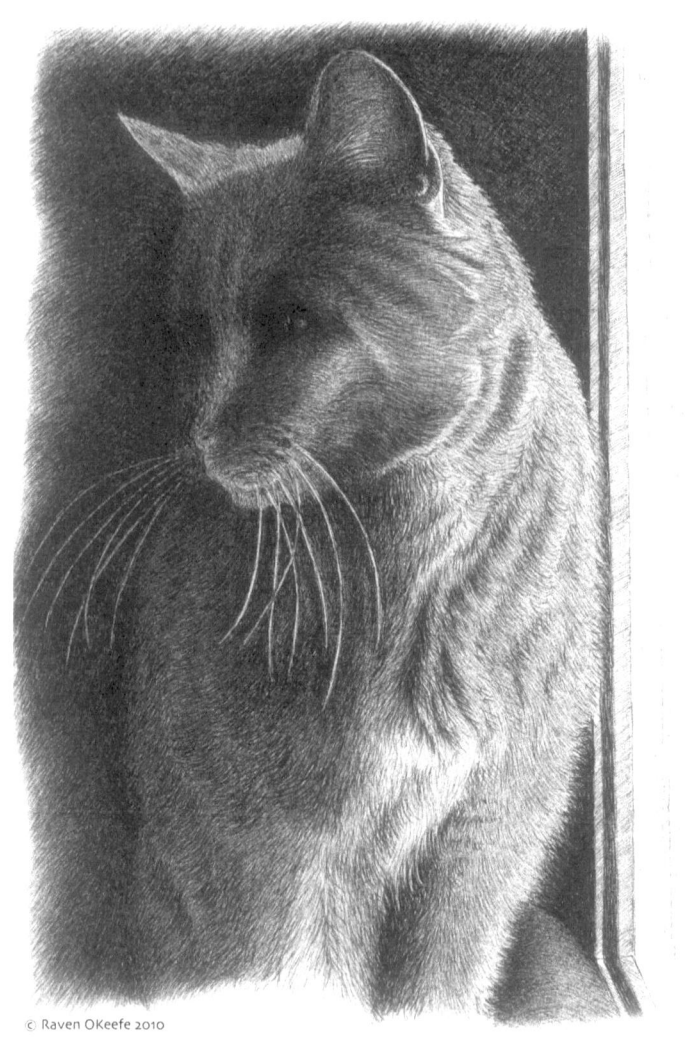

Bailey

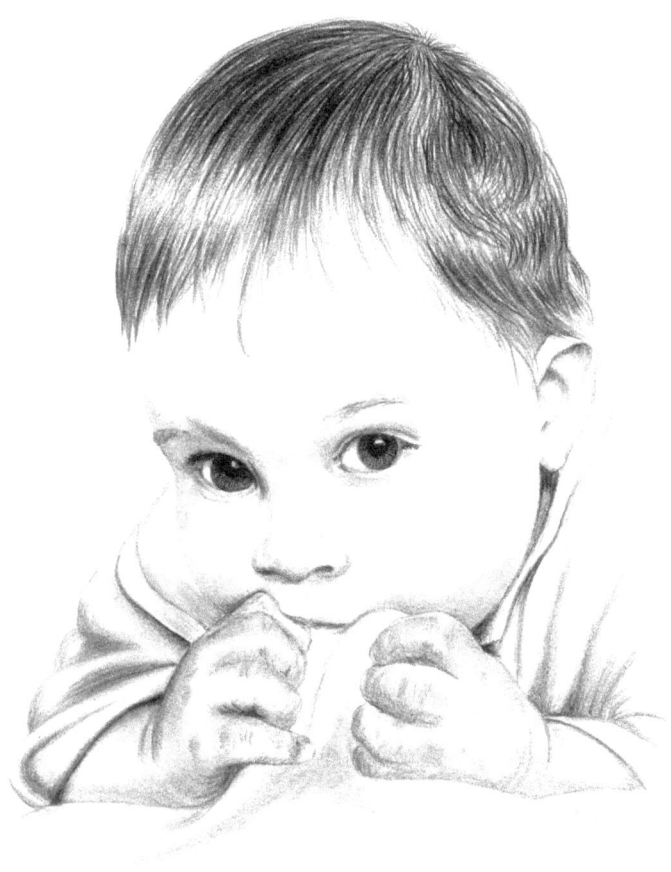

© Raven OKeefe

Baby face

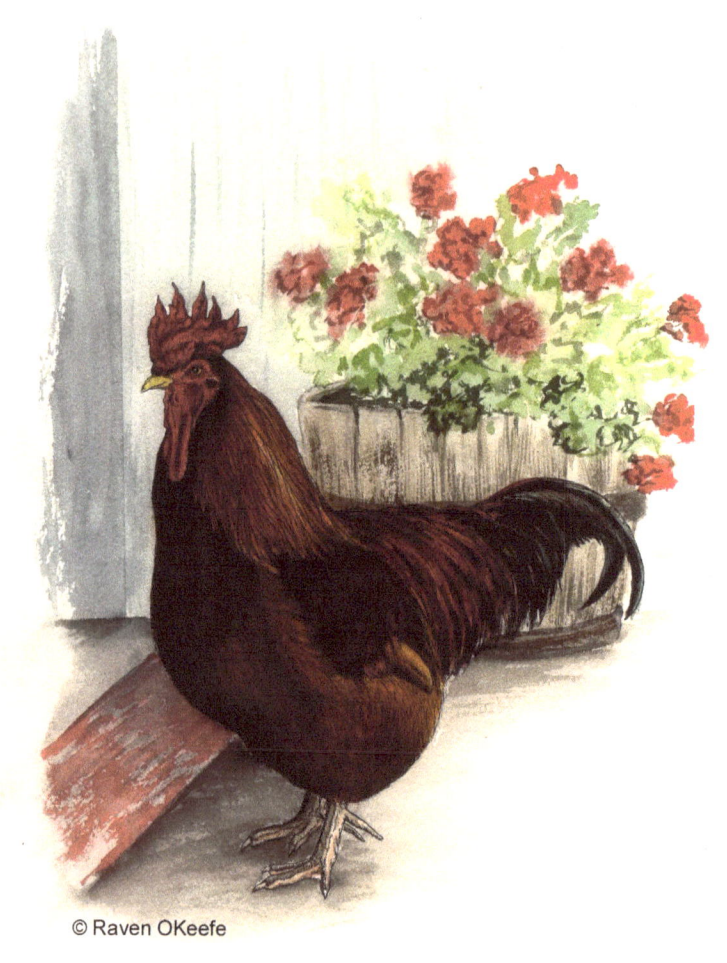

Big Red

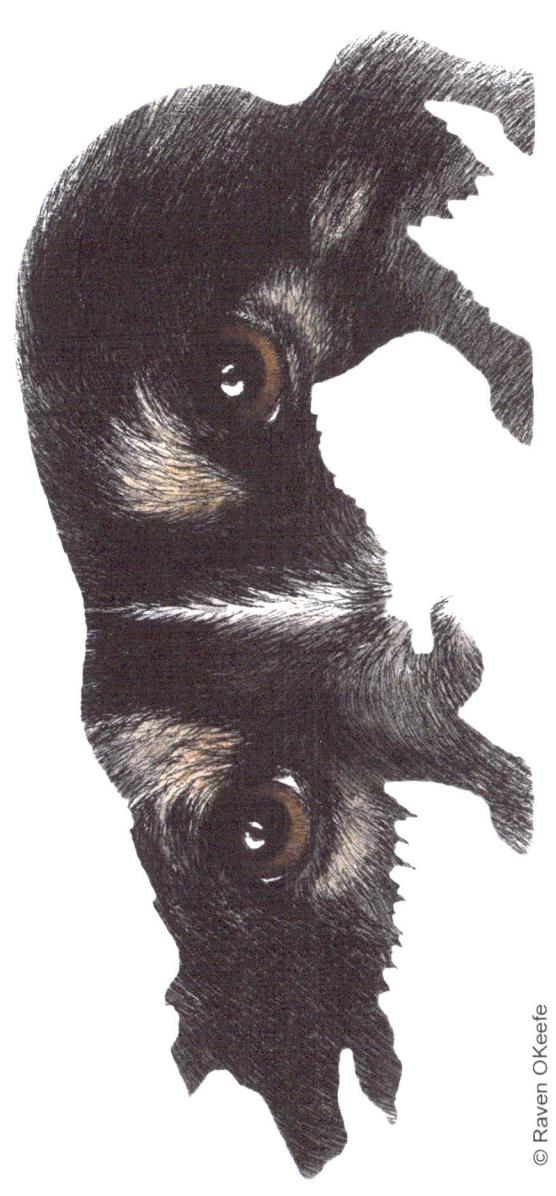

BC eyes

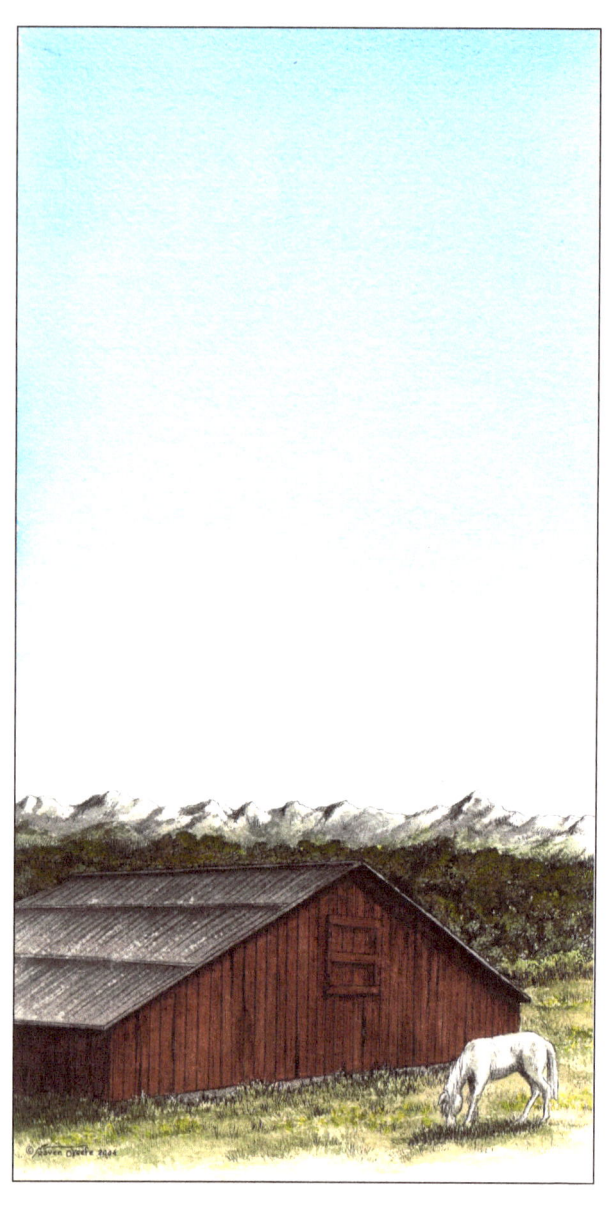

Big sky

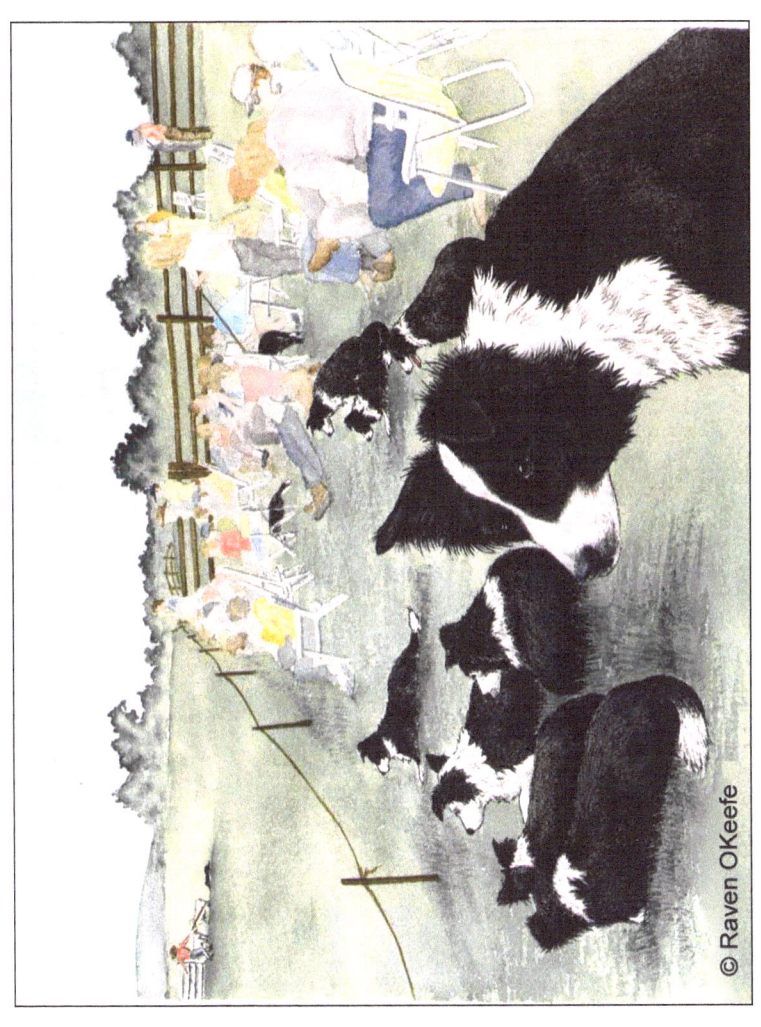

At the trial

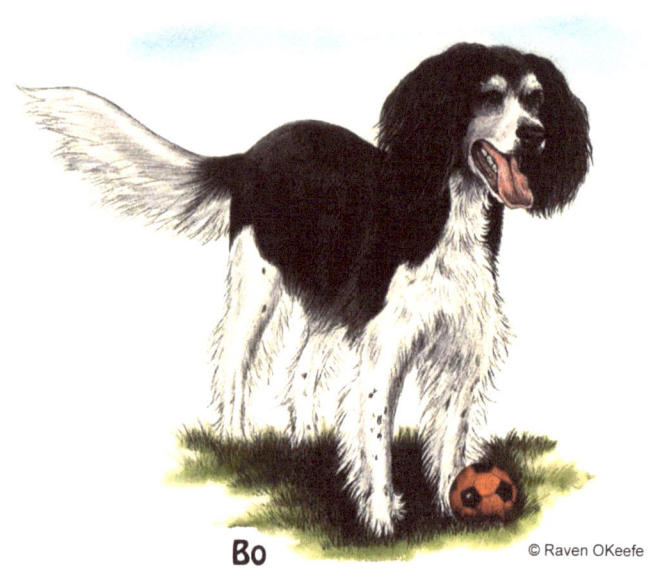

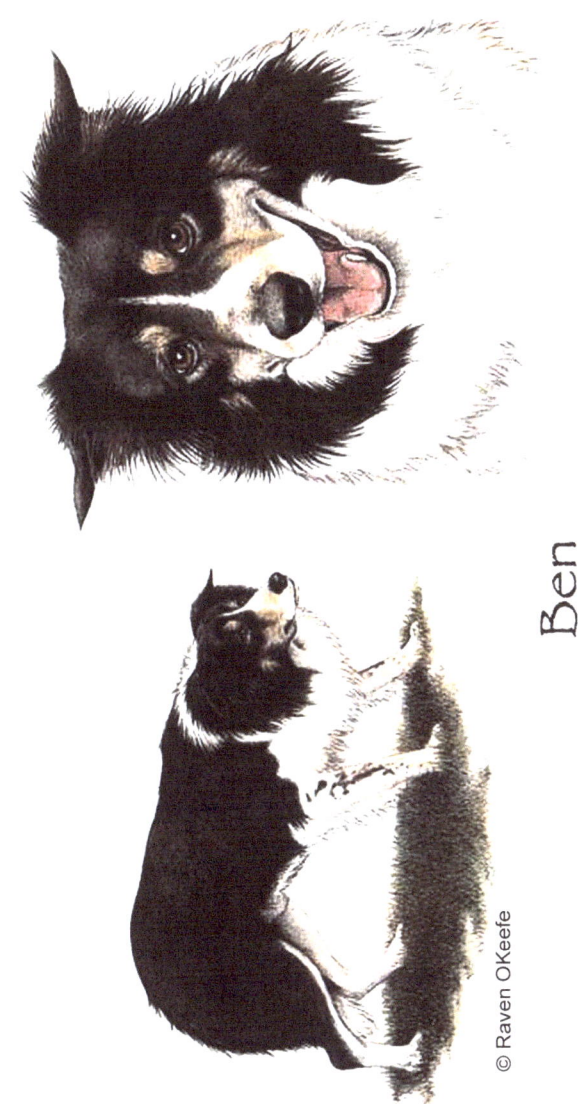
Ben
© Raven OKeefe

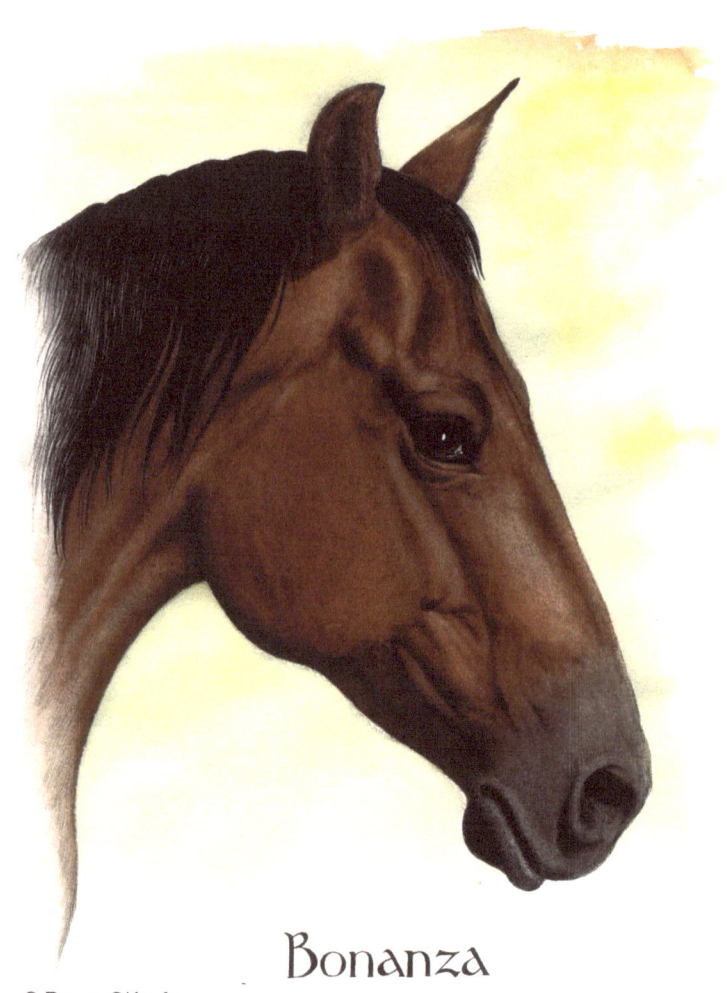

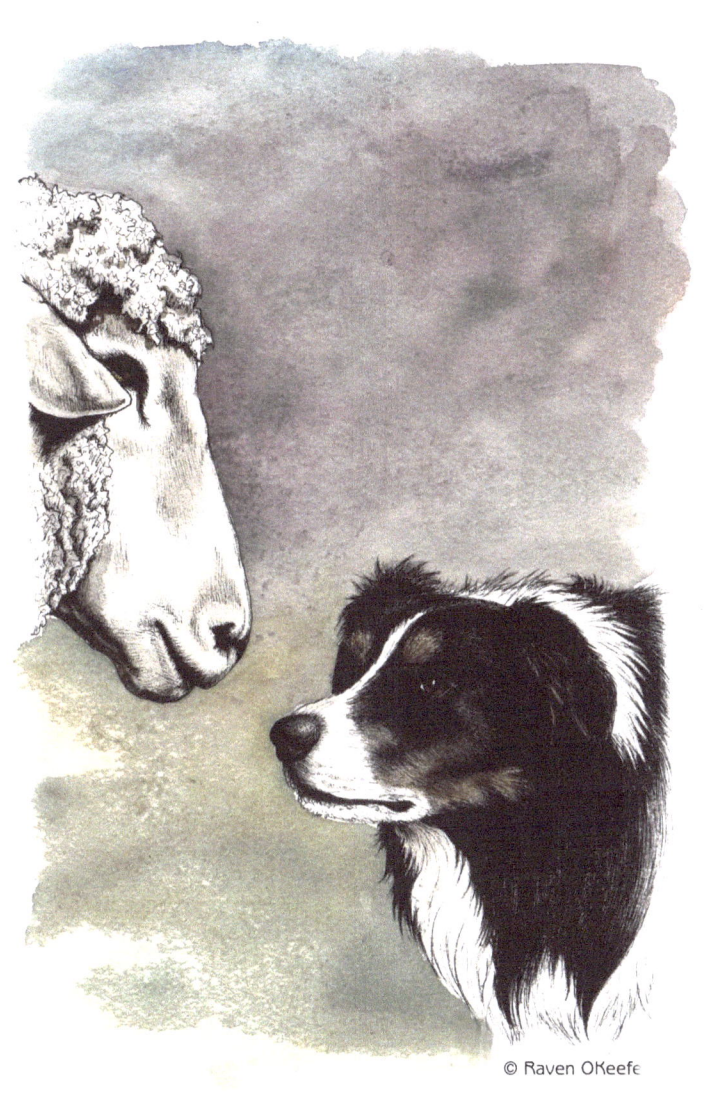

Face off

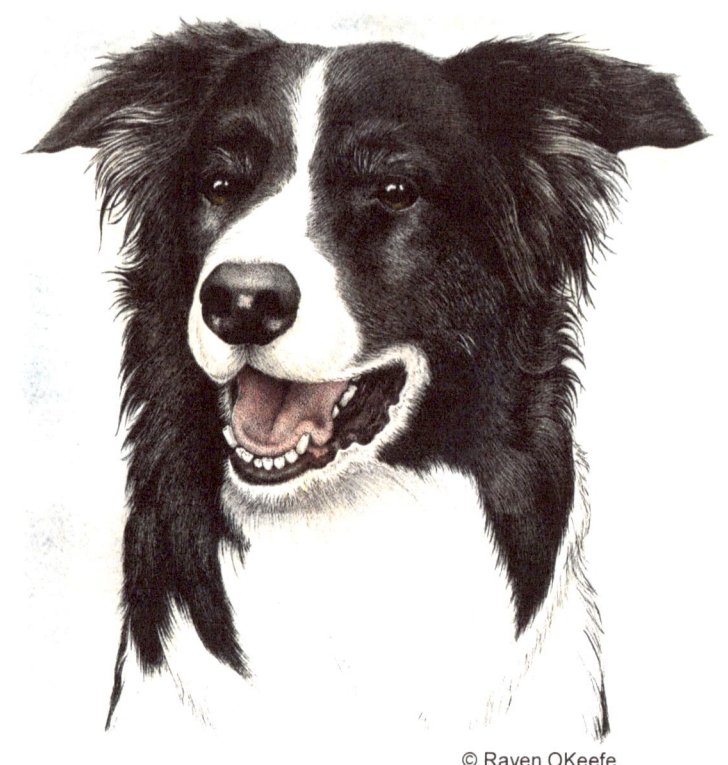

© Raven OKeefe

Boone

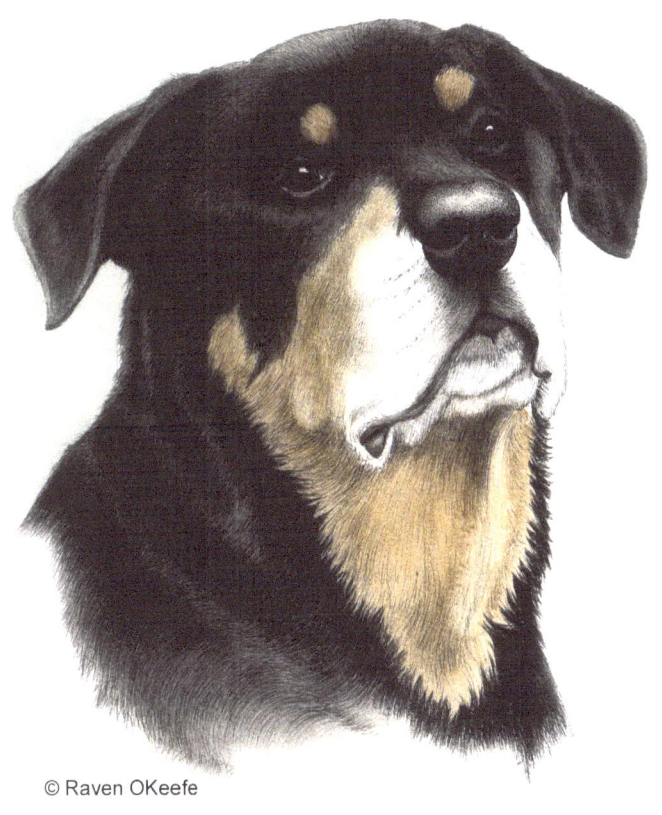

Charlie

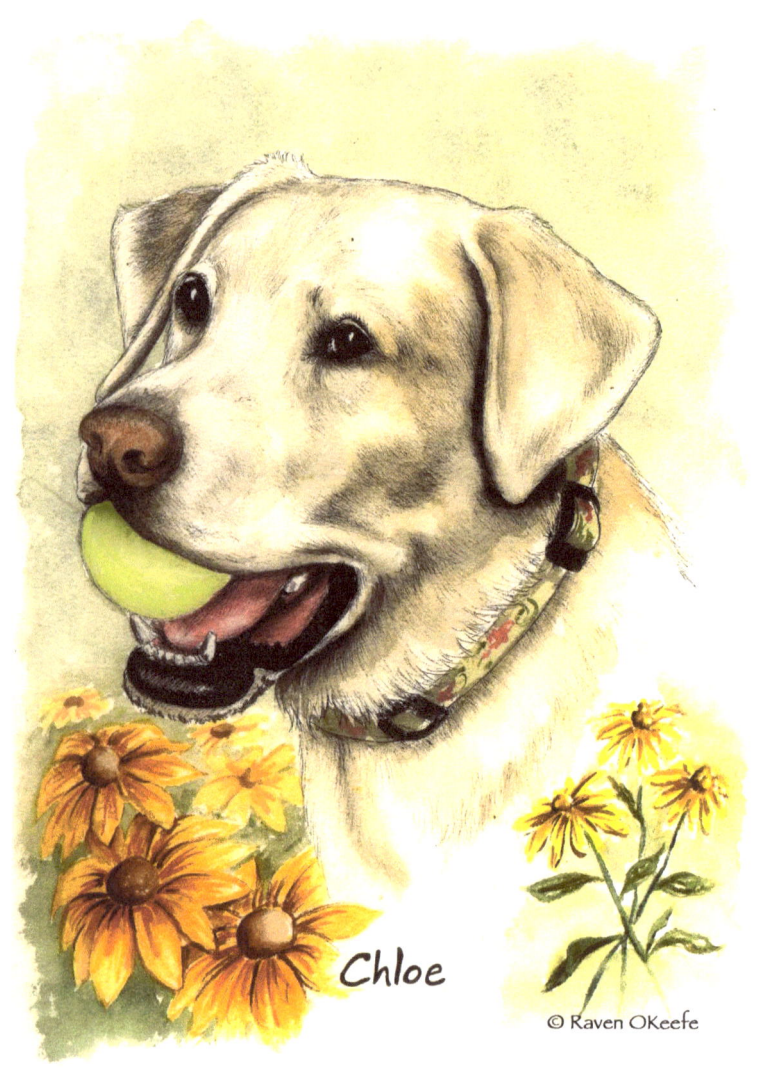

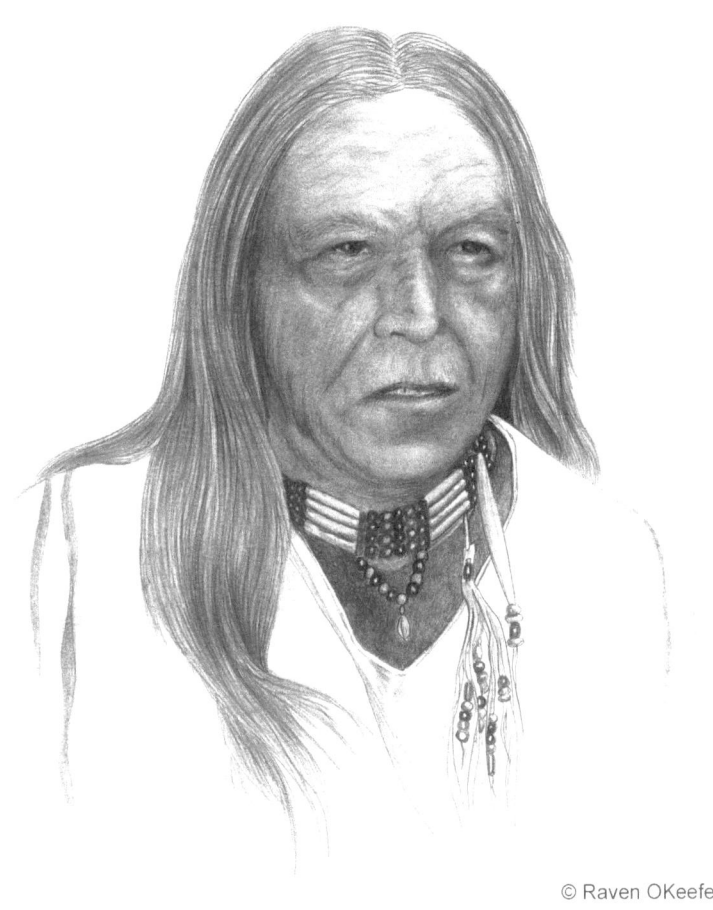

Elder

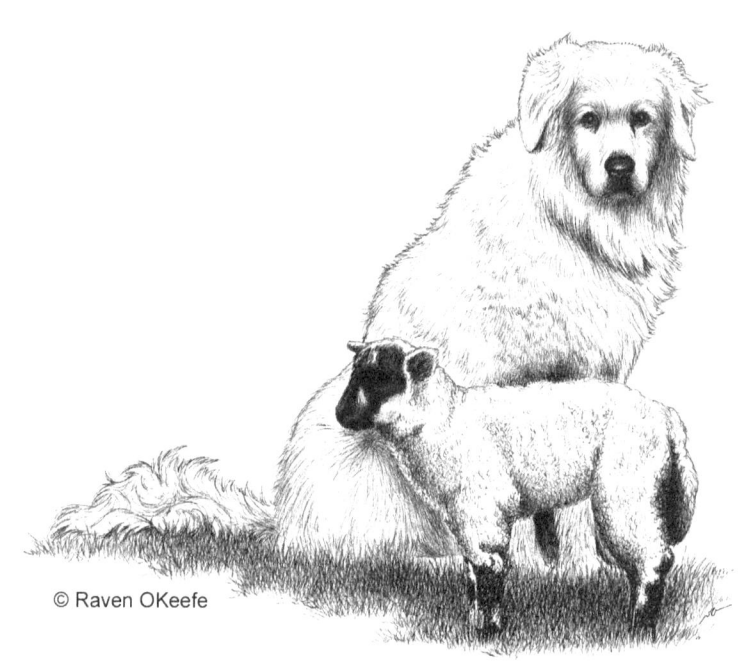

Cleo

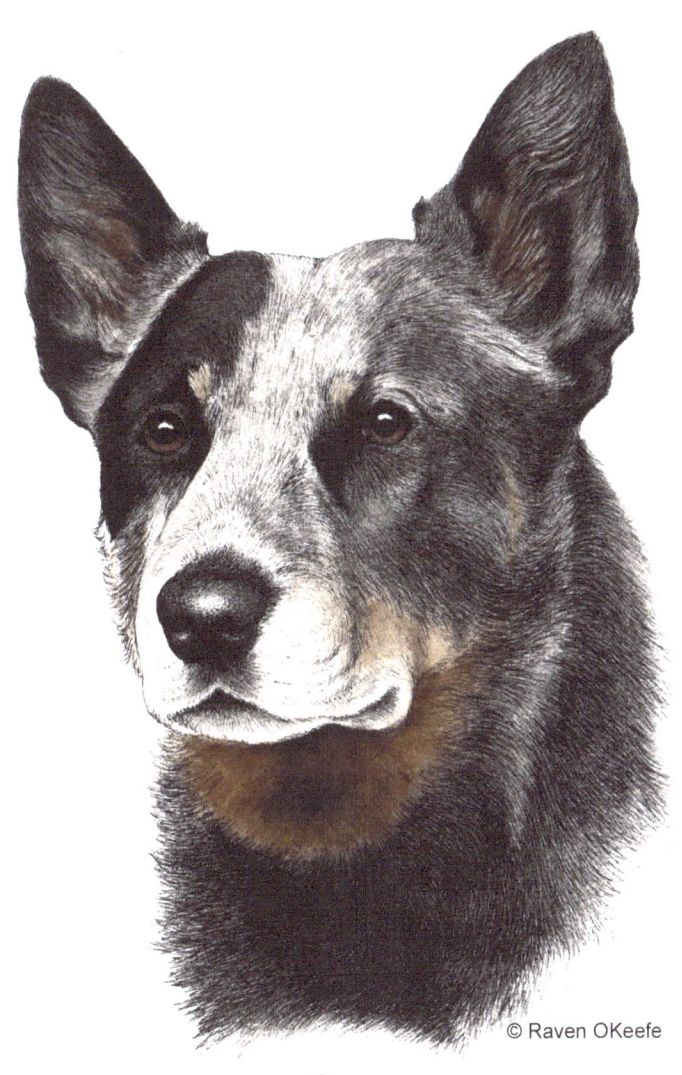

Cory

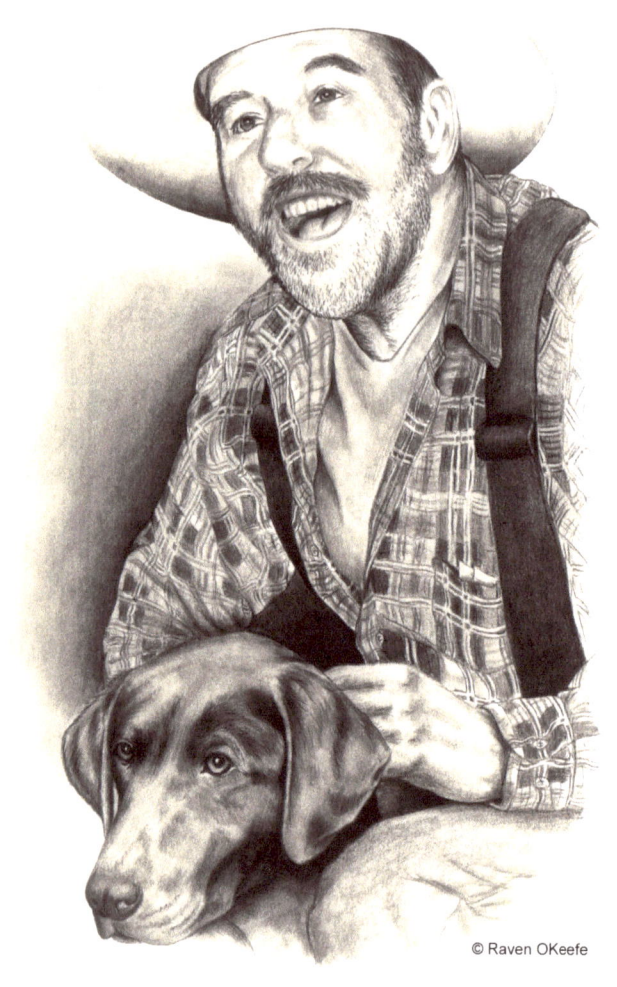

Dave St. John & Tucker

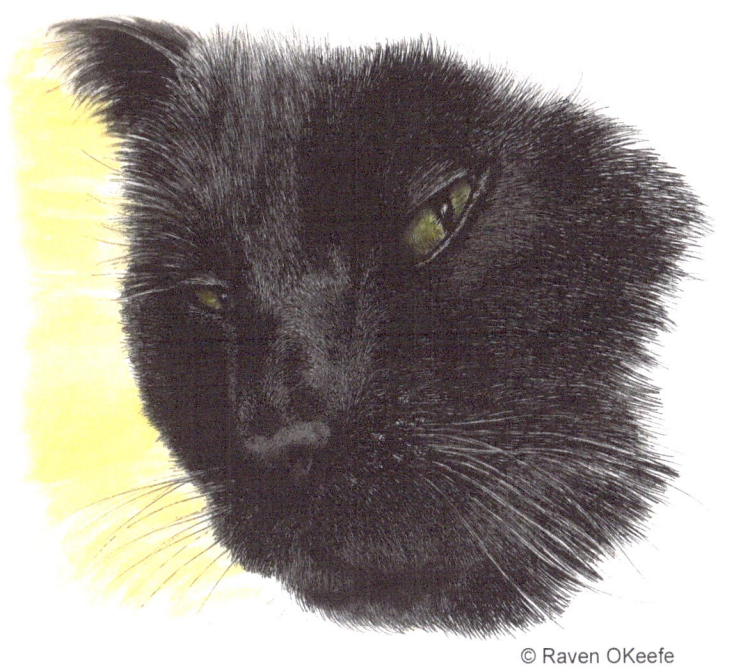

Flakey Jake

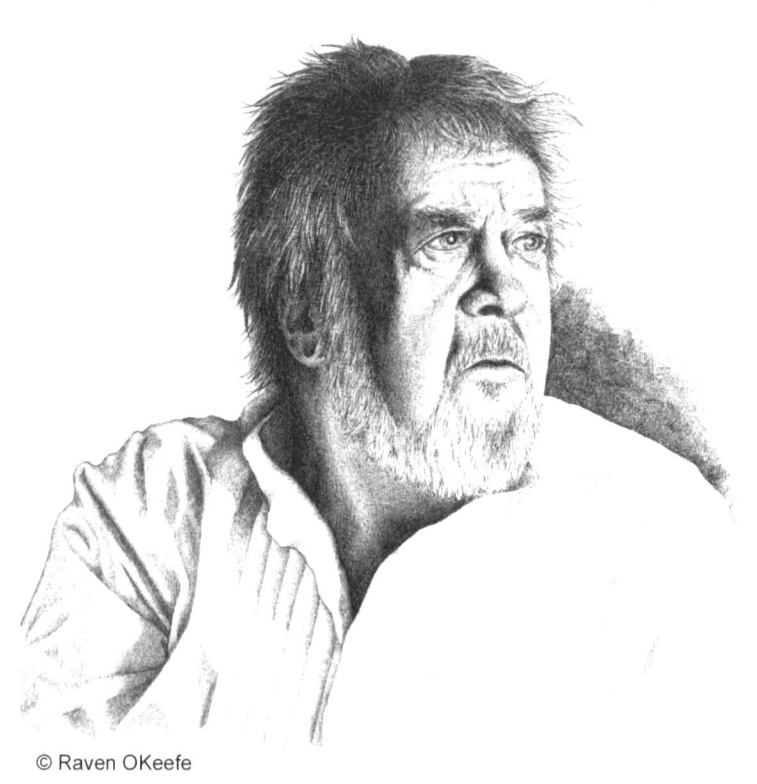
© Raven OKeefe

Frank

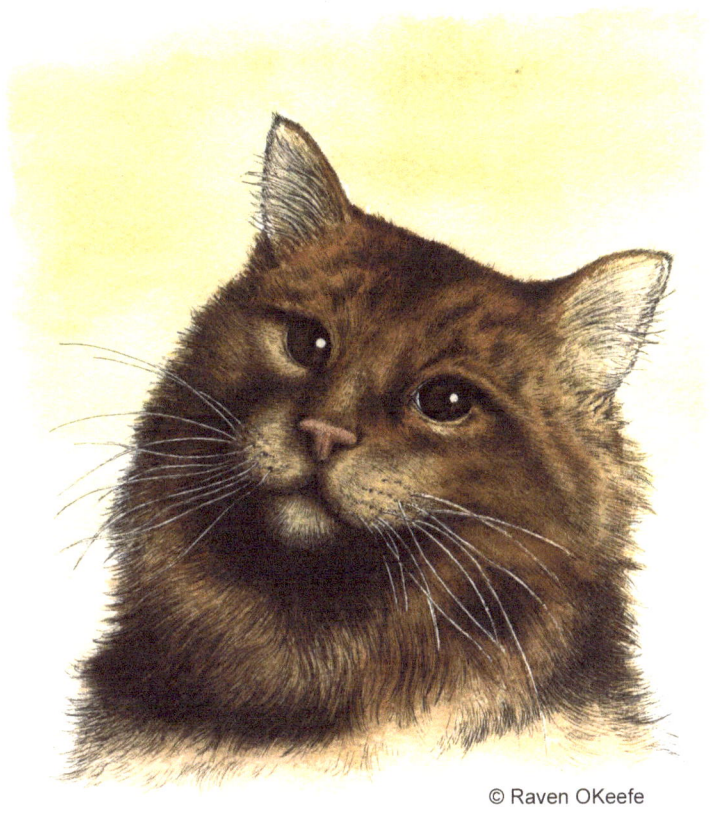

Griz

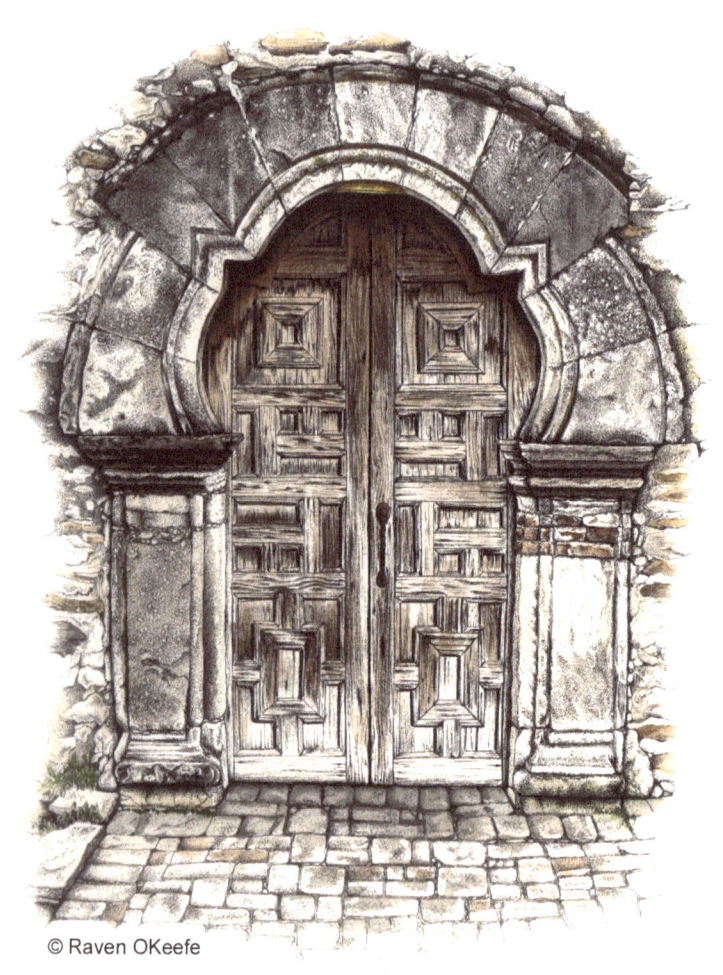

Espada Mission Door

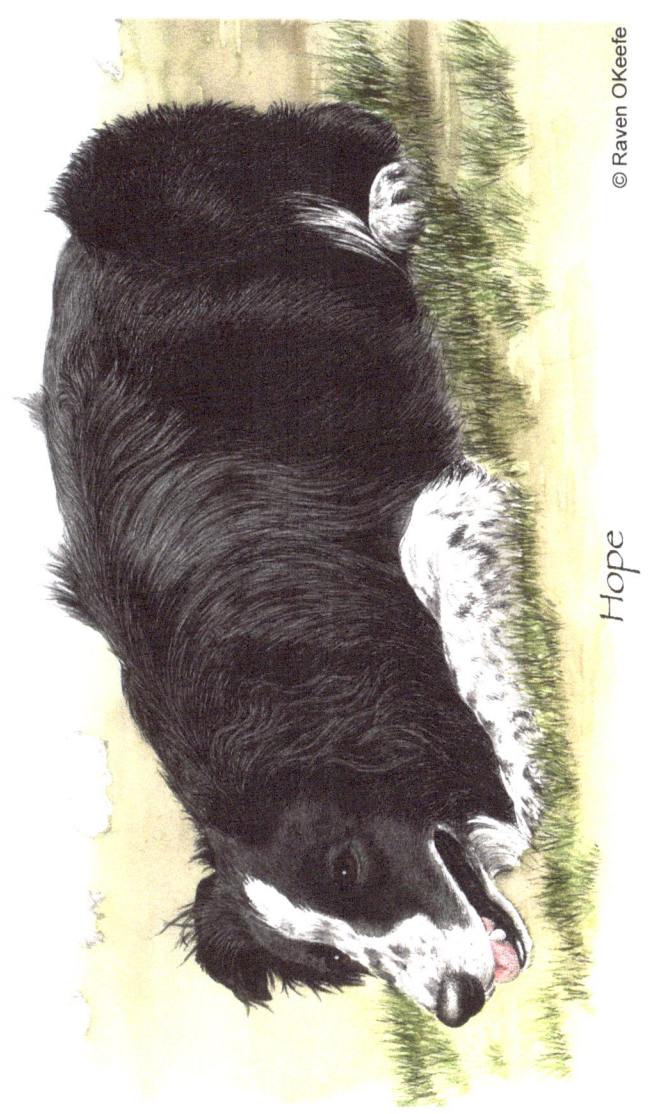

Hope

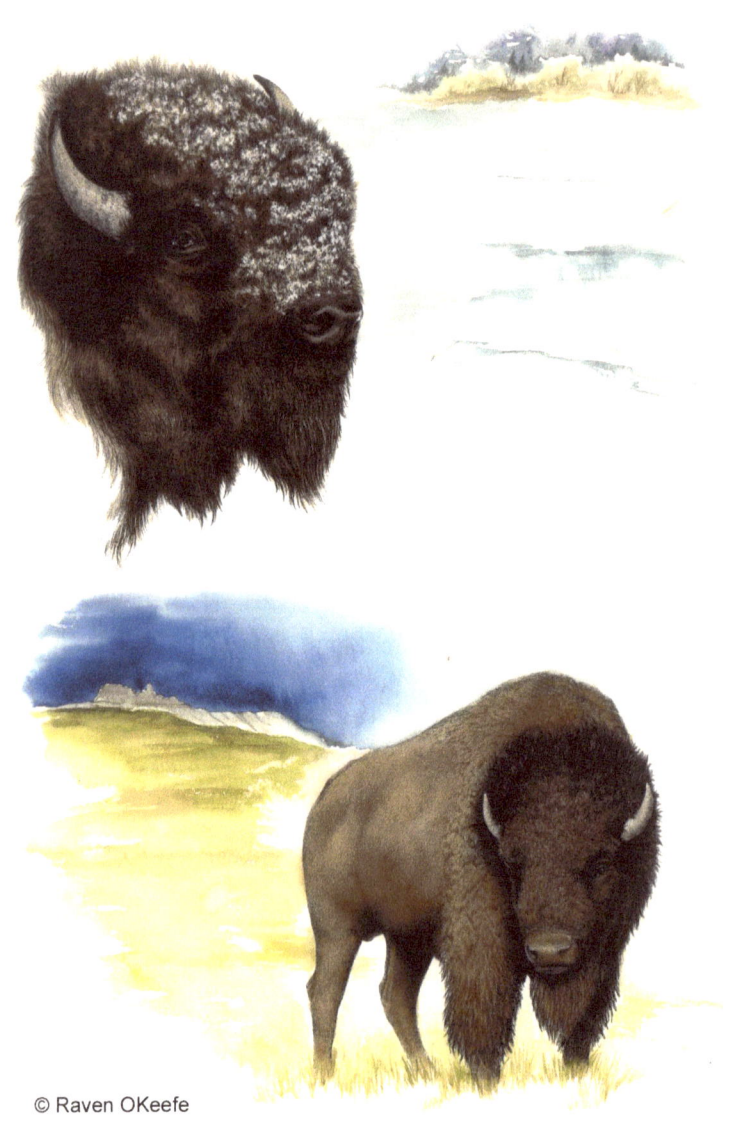

© Raven OKeefe

Faces the Blizzard

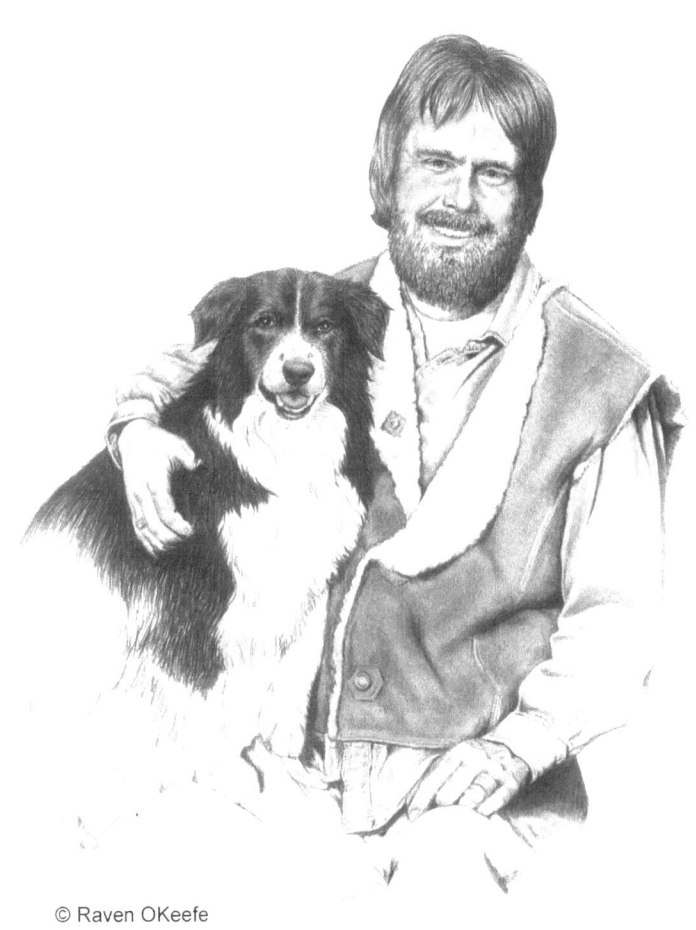
© Raven OKeefe

Ian & Moss

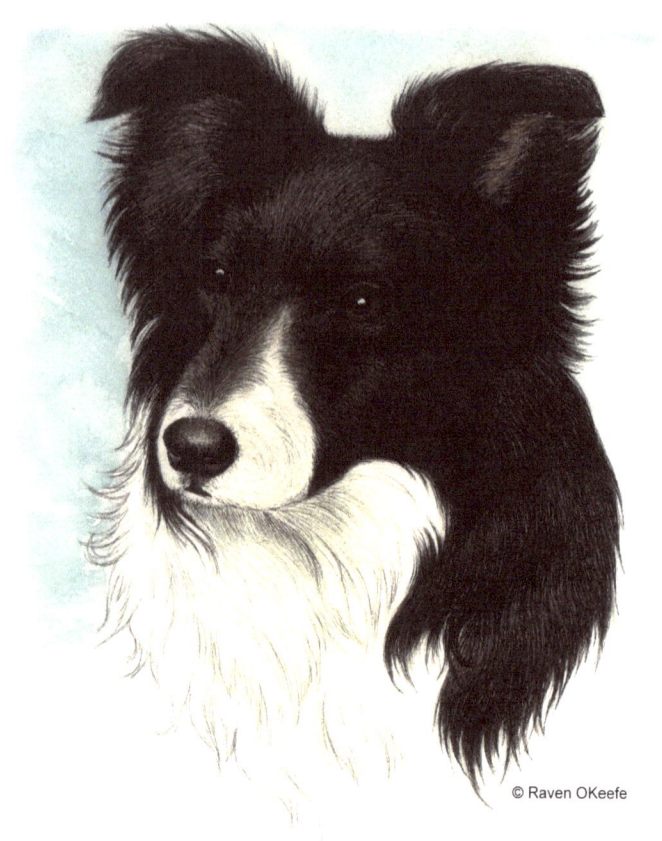

JoeKidd

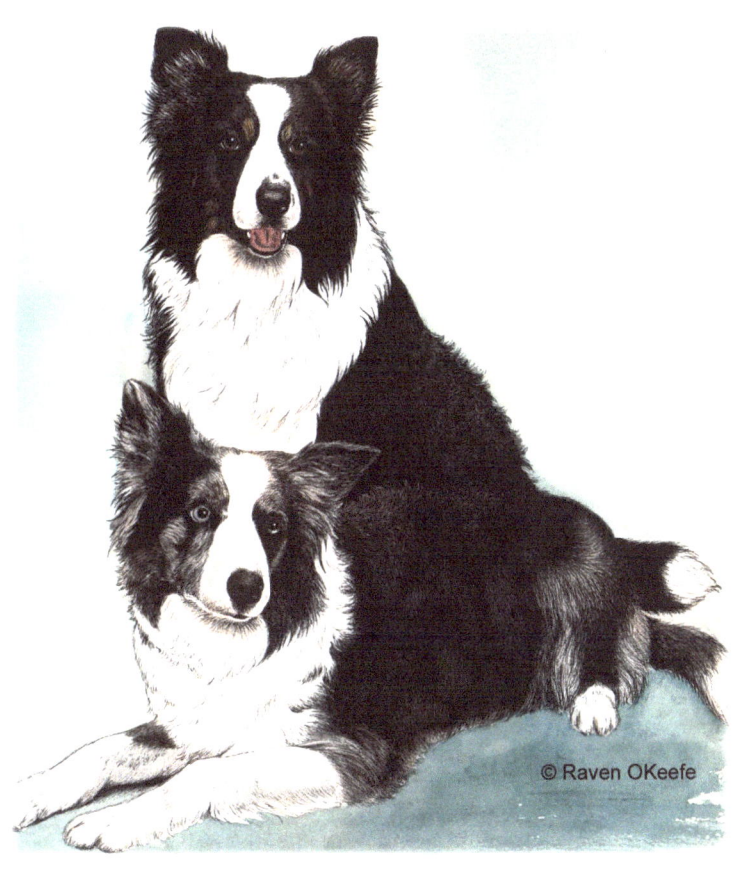

Judd & Bounce

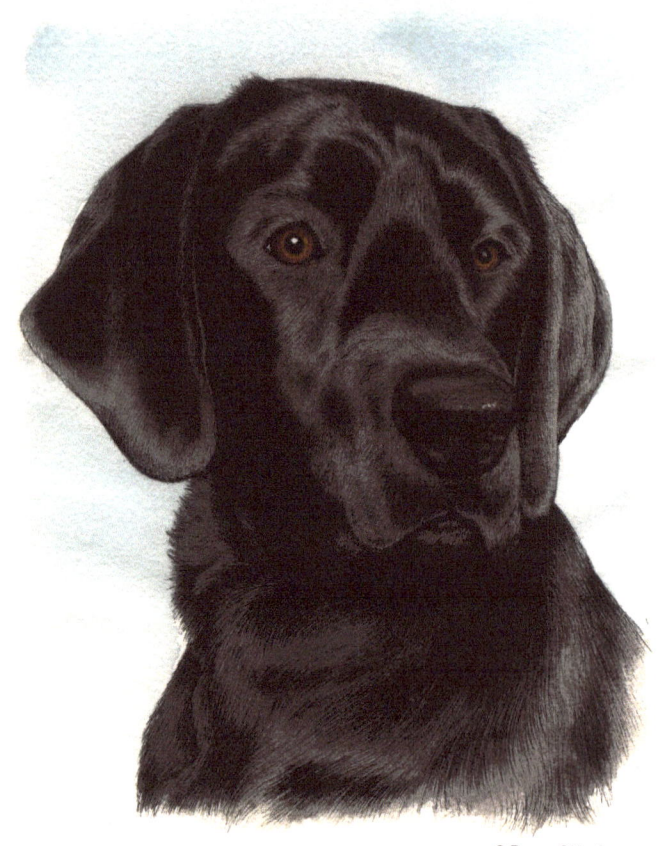

Katie

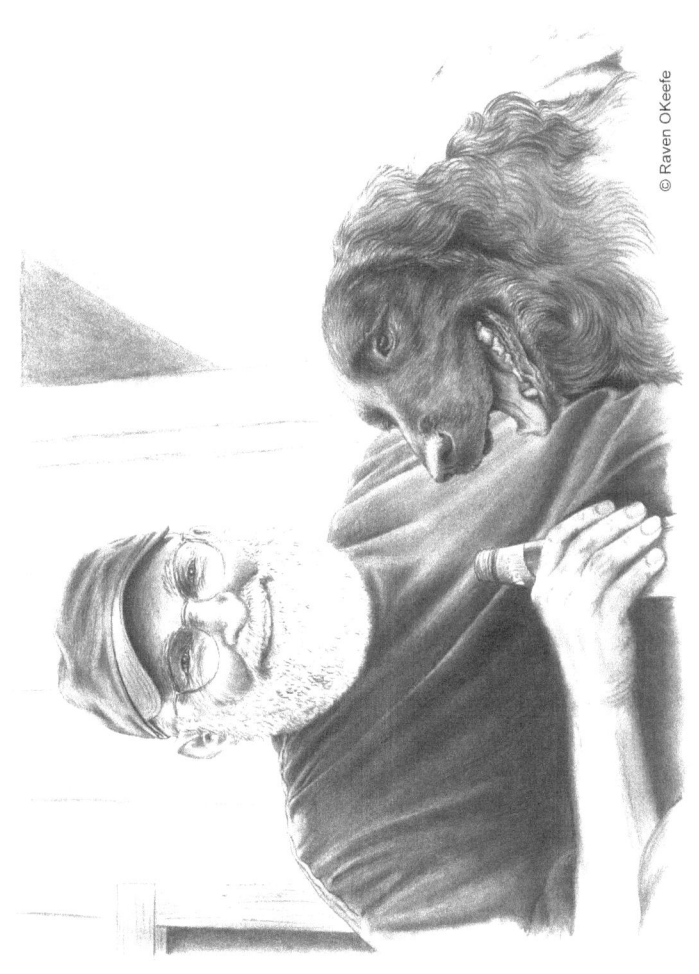

John Herrmann & Shadow

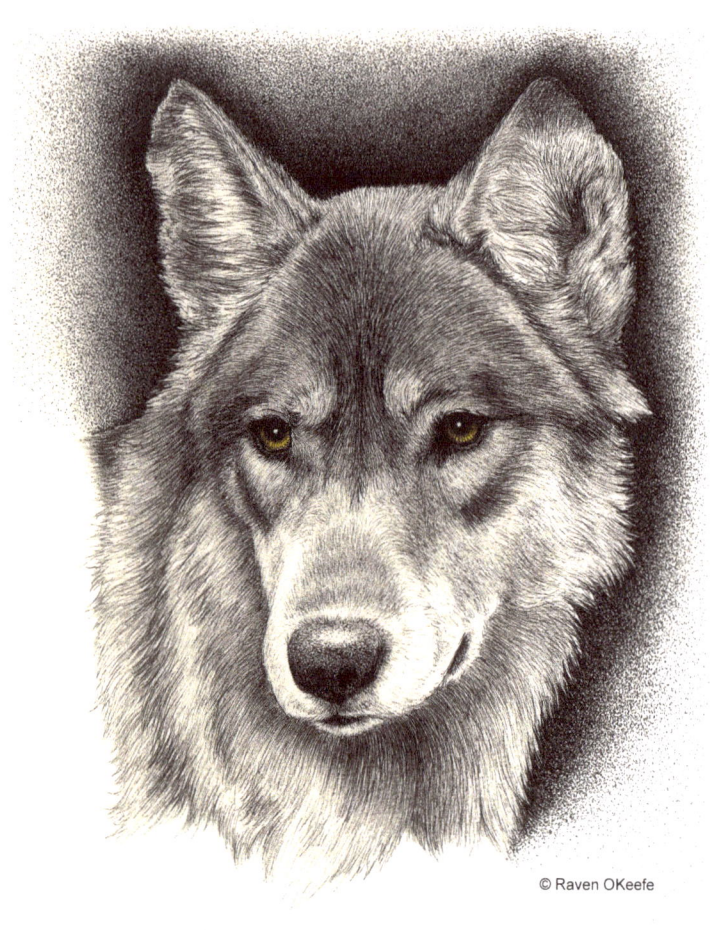

Mom's Wolf

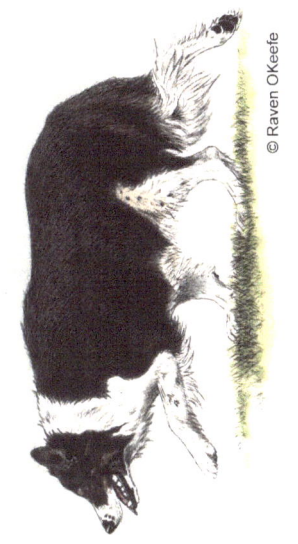

MacIntosh

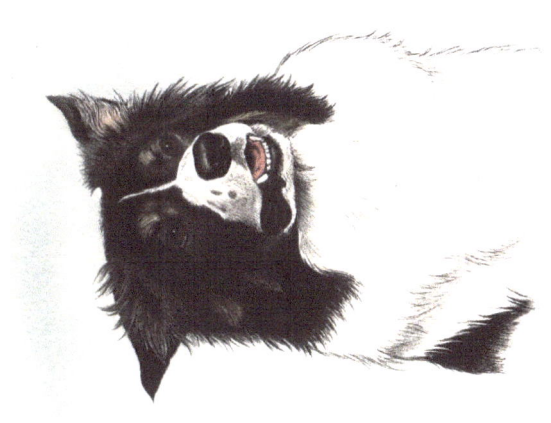

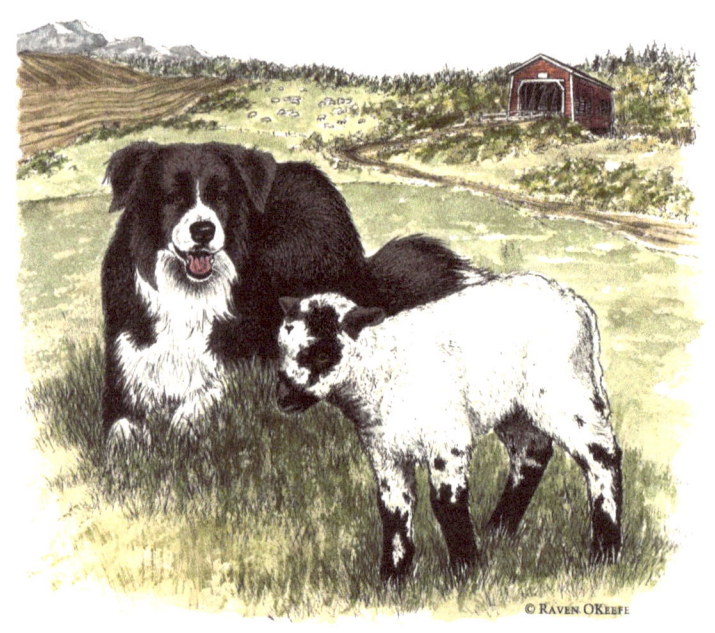

Moss & Minnie

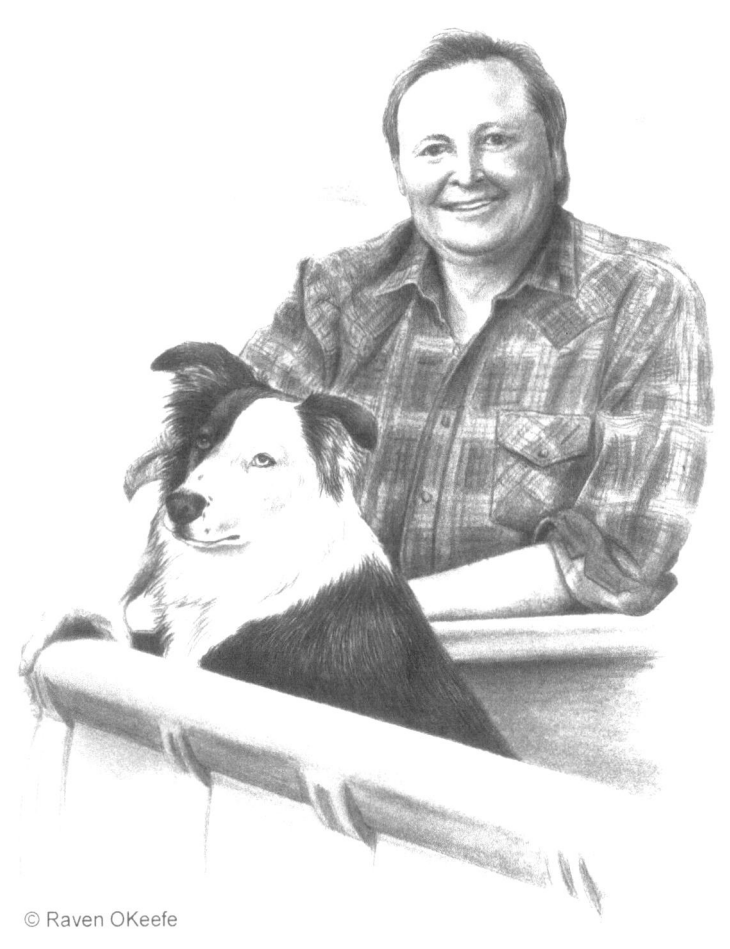
© Raven OKeefe

Montana Governor Brian Schweitzer & Jag

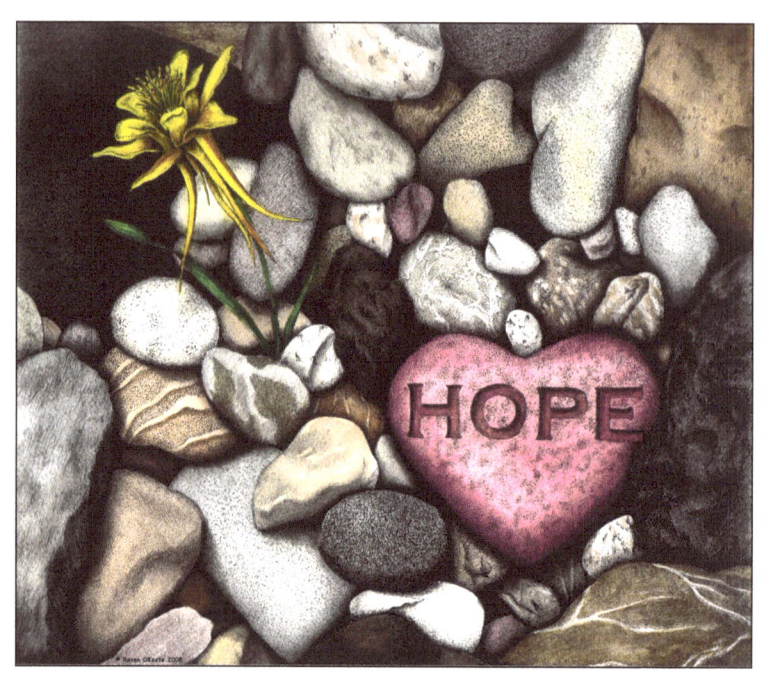

Portrait of Hope

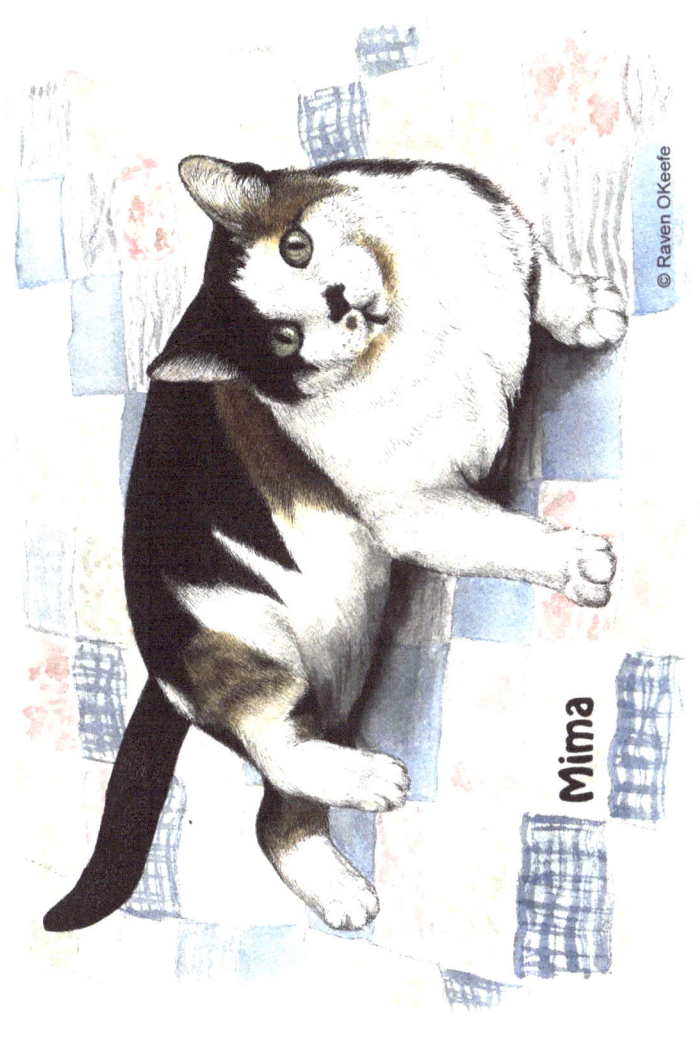

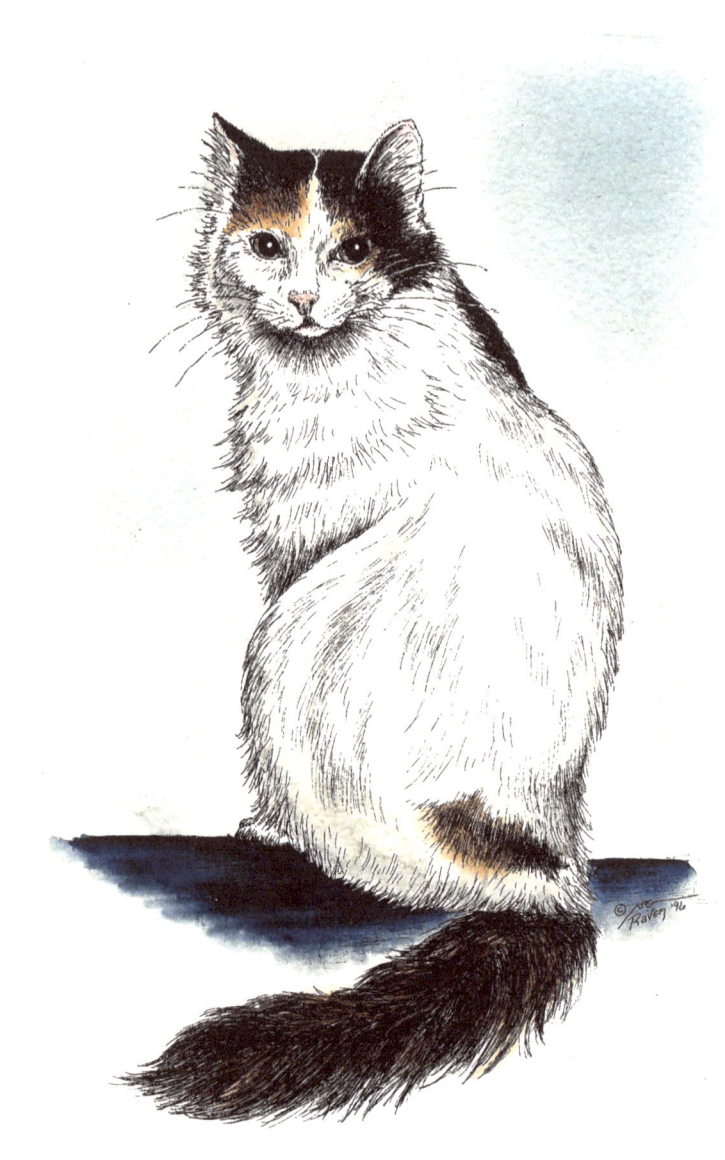

Rocket J. Squirrel

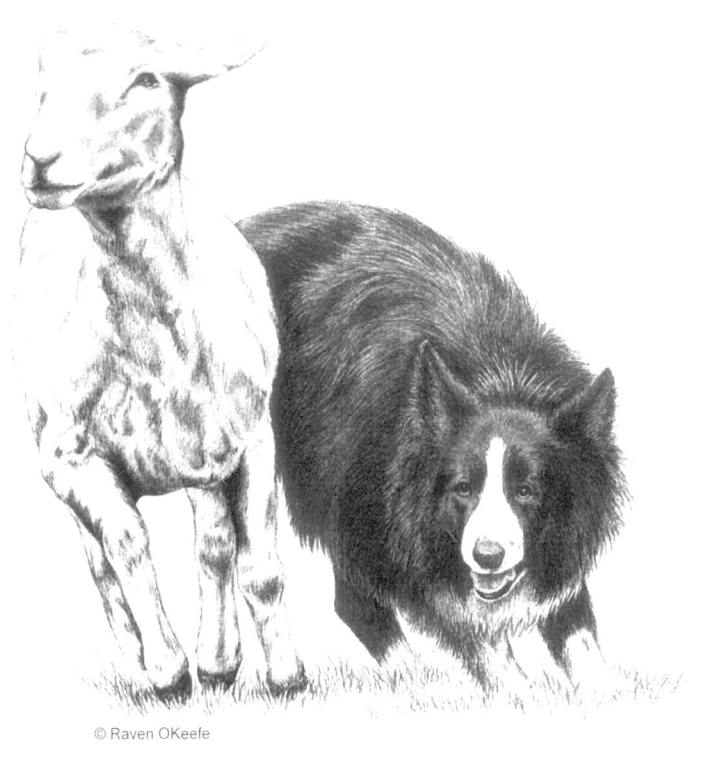

Run, Mickey, Run!

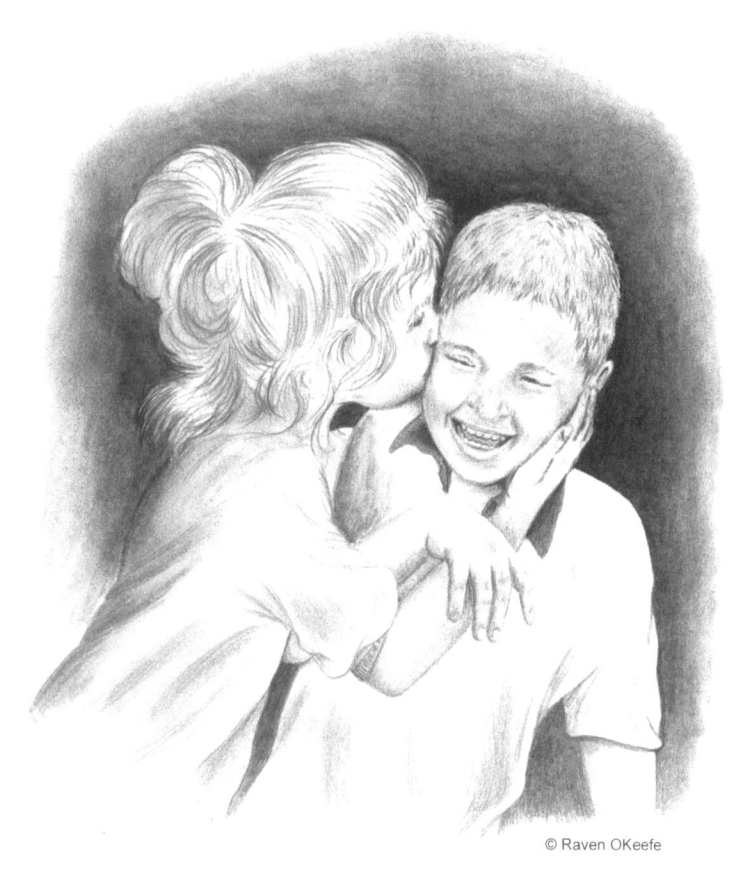

Shy guy

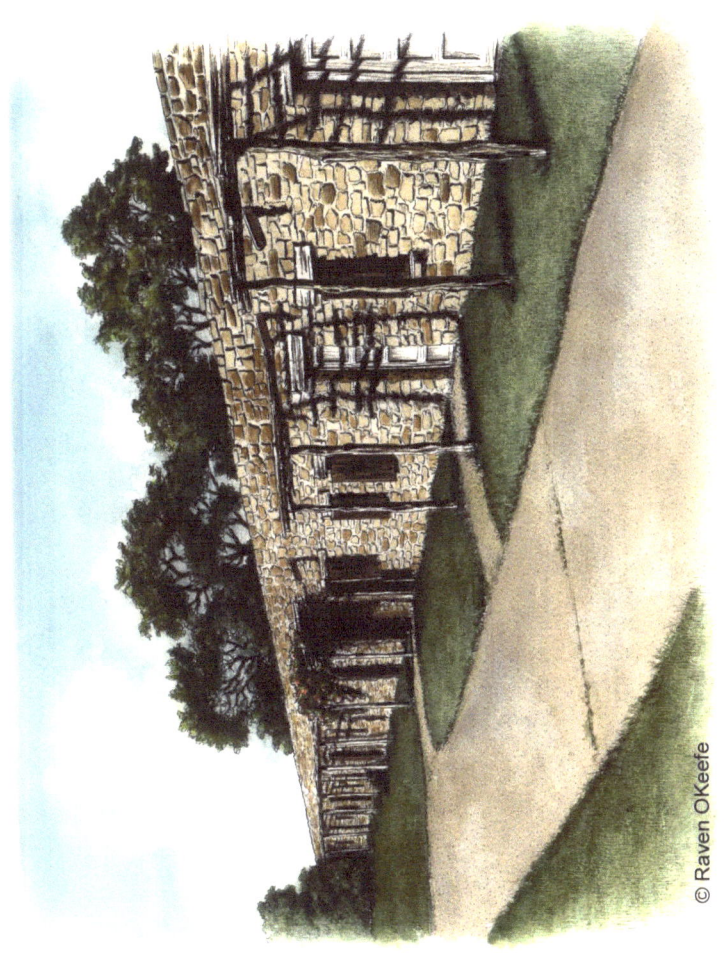

San Jose Mission

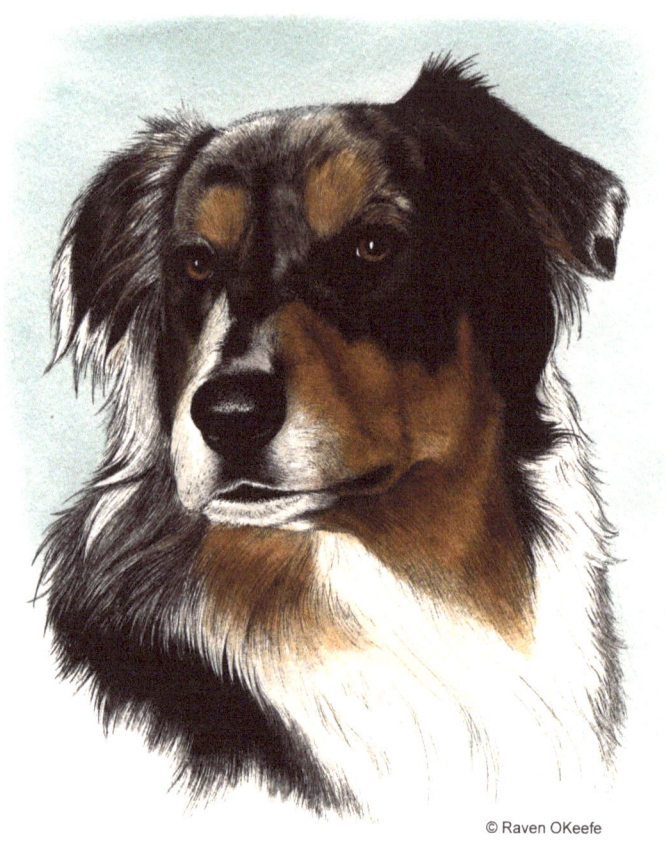

Star

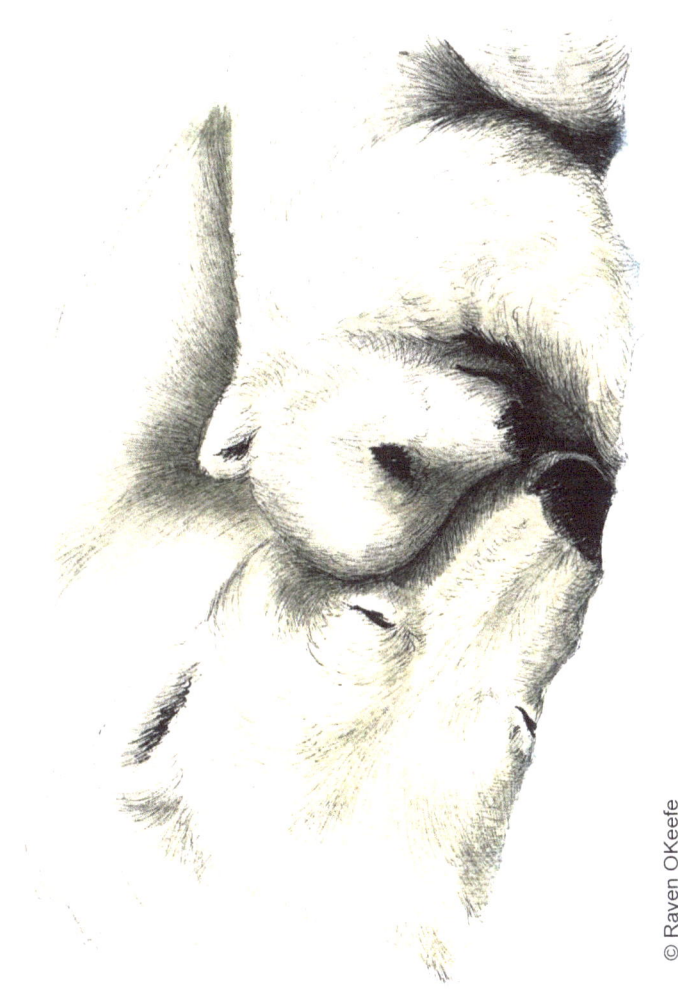

Snowy snooze

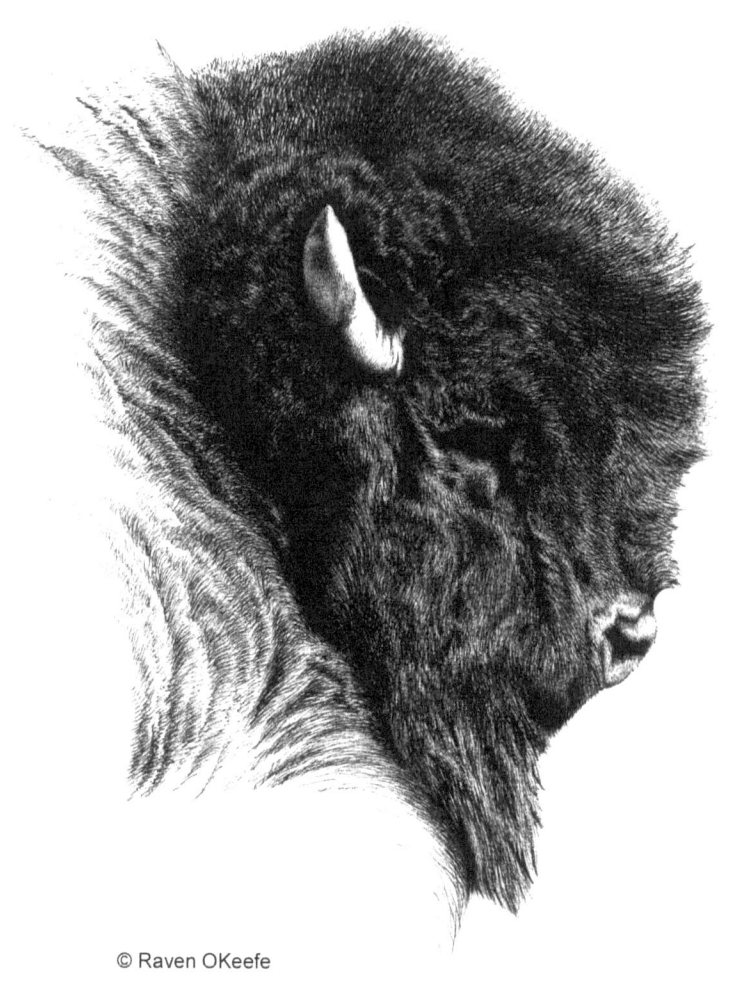

© Raven OKeefe

Tatanka

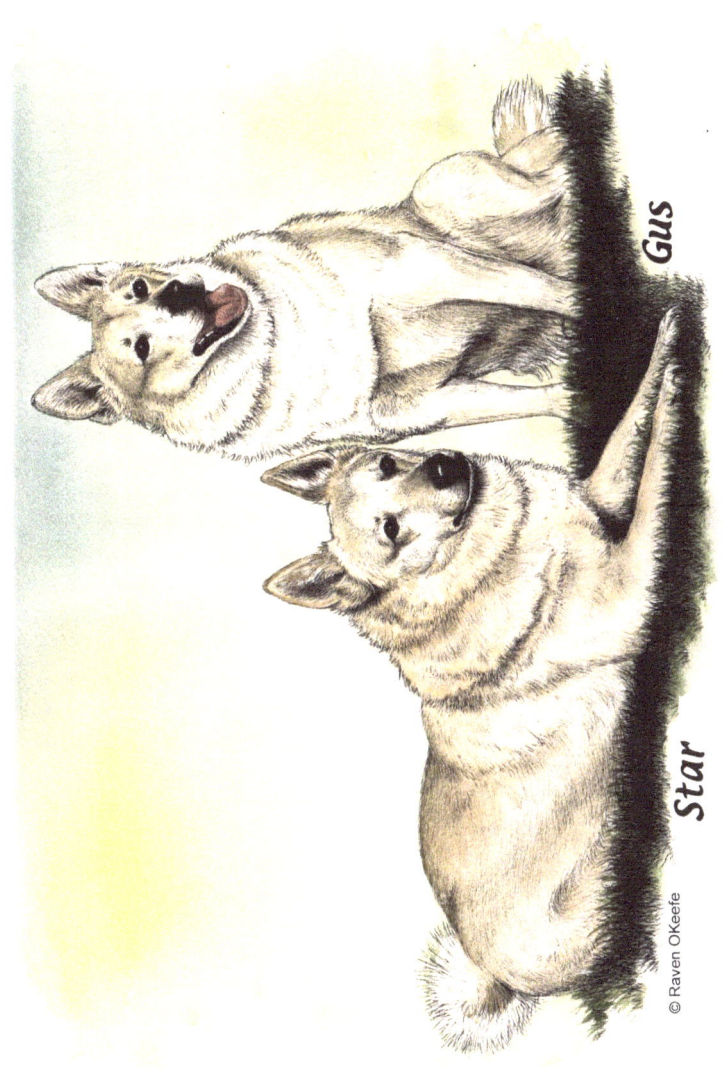

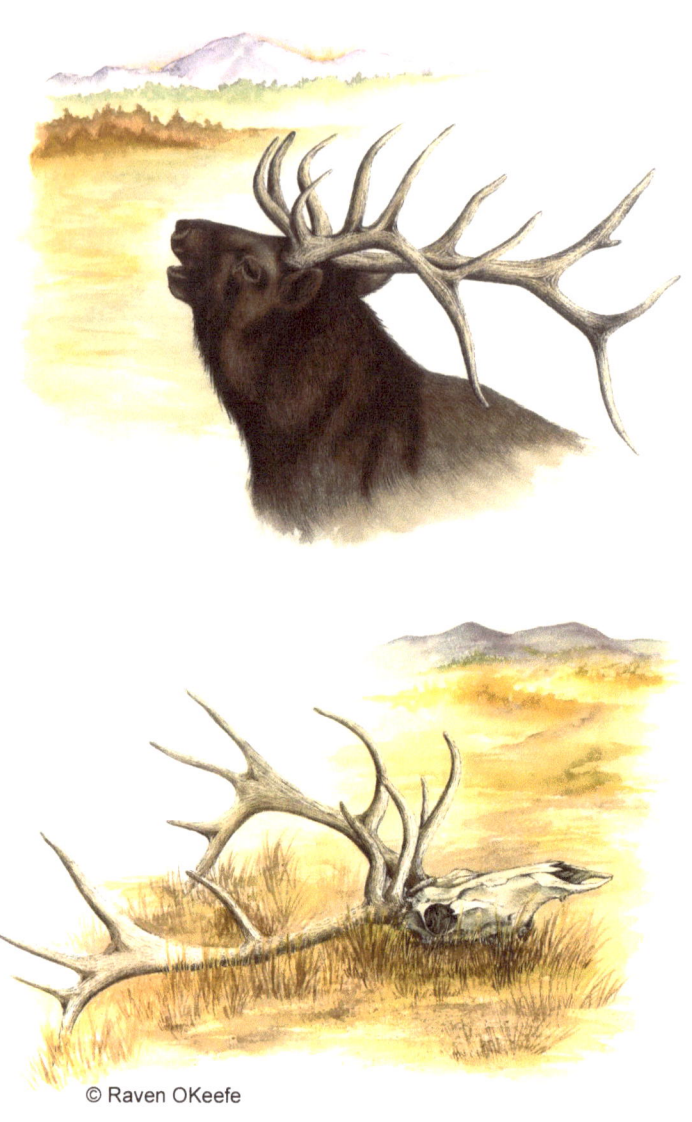

The Bugler, then and now

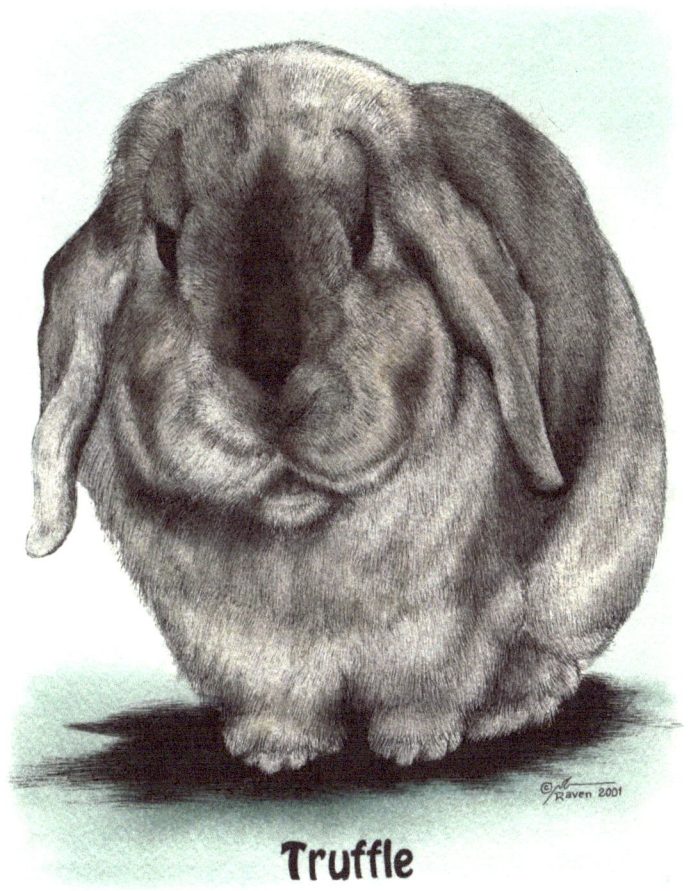

Truffle

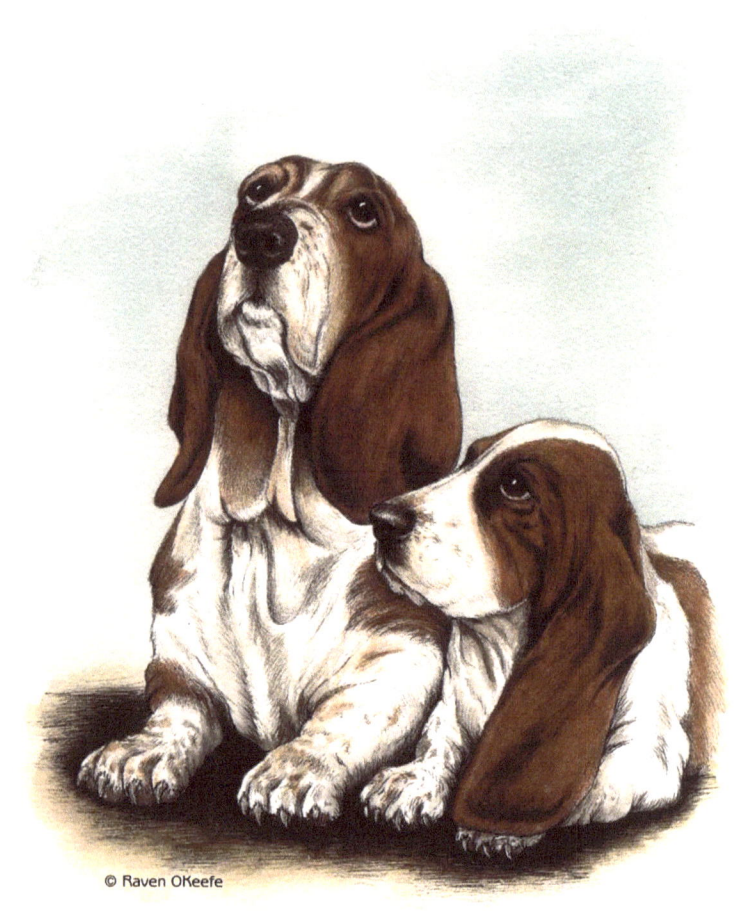

We two

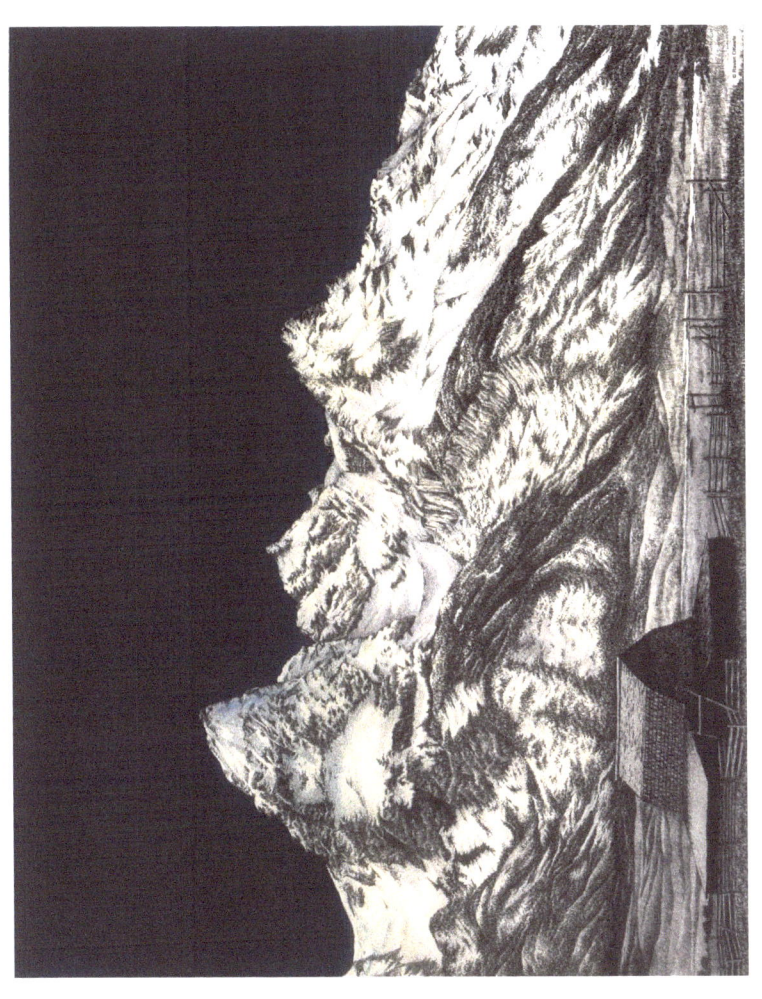

The Grand Tetons

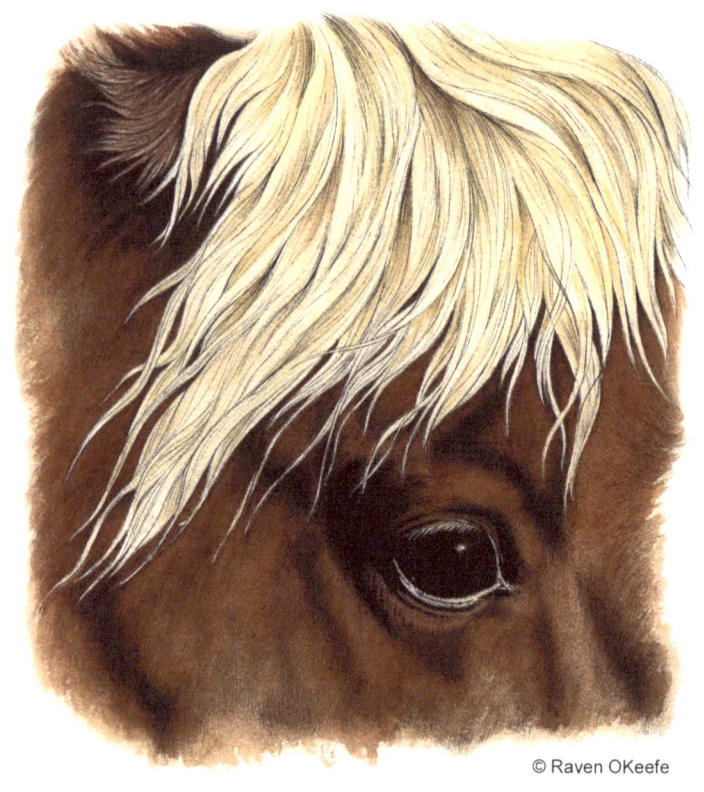

Window to the Soul

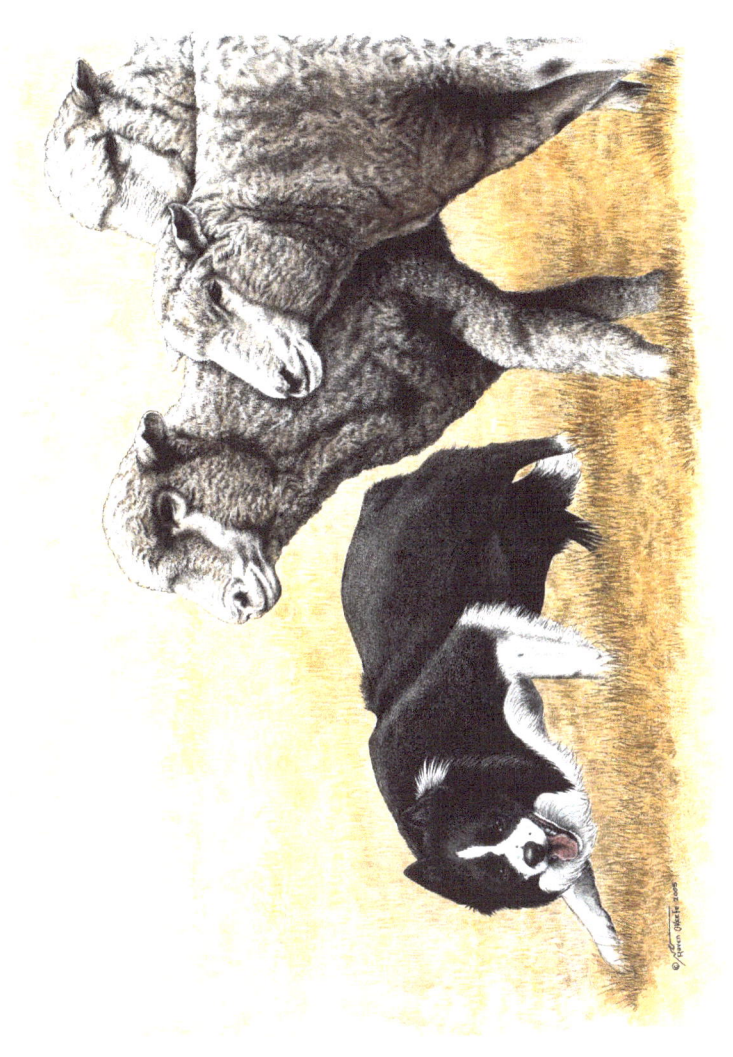

Turning point

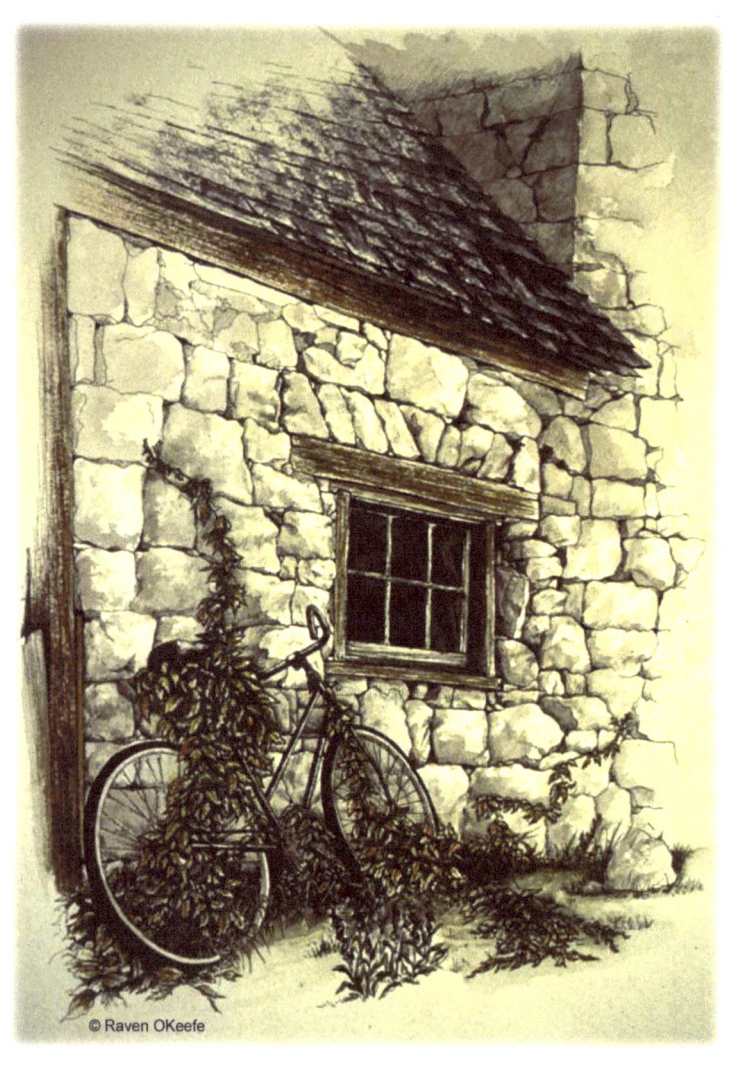

Two-wheel trellis

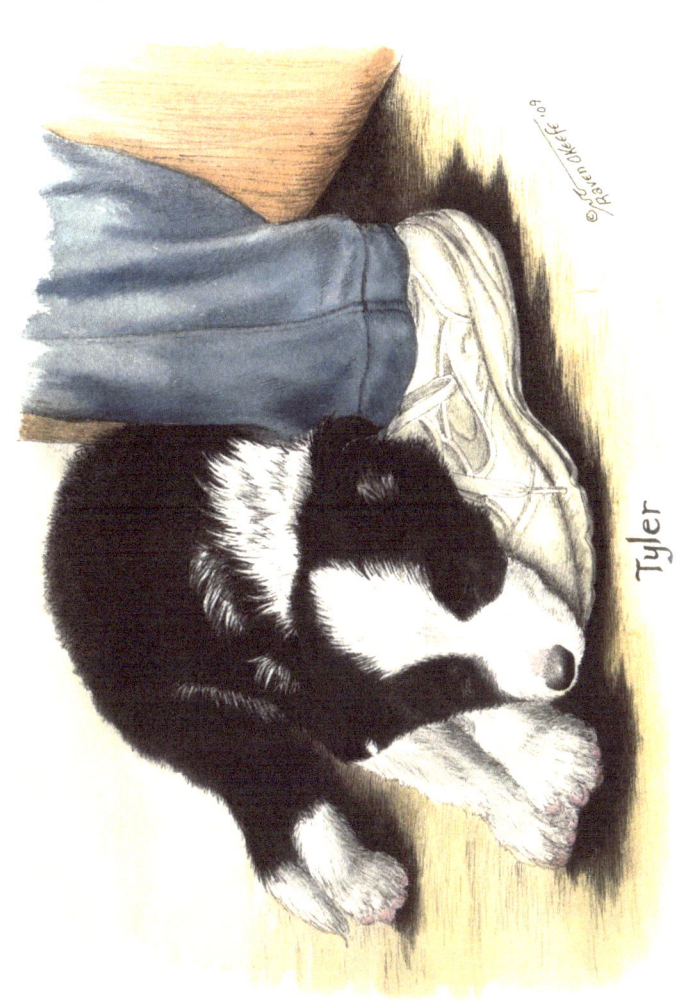

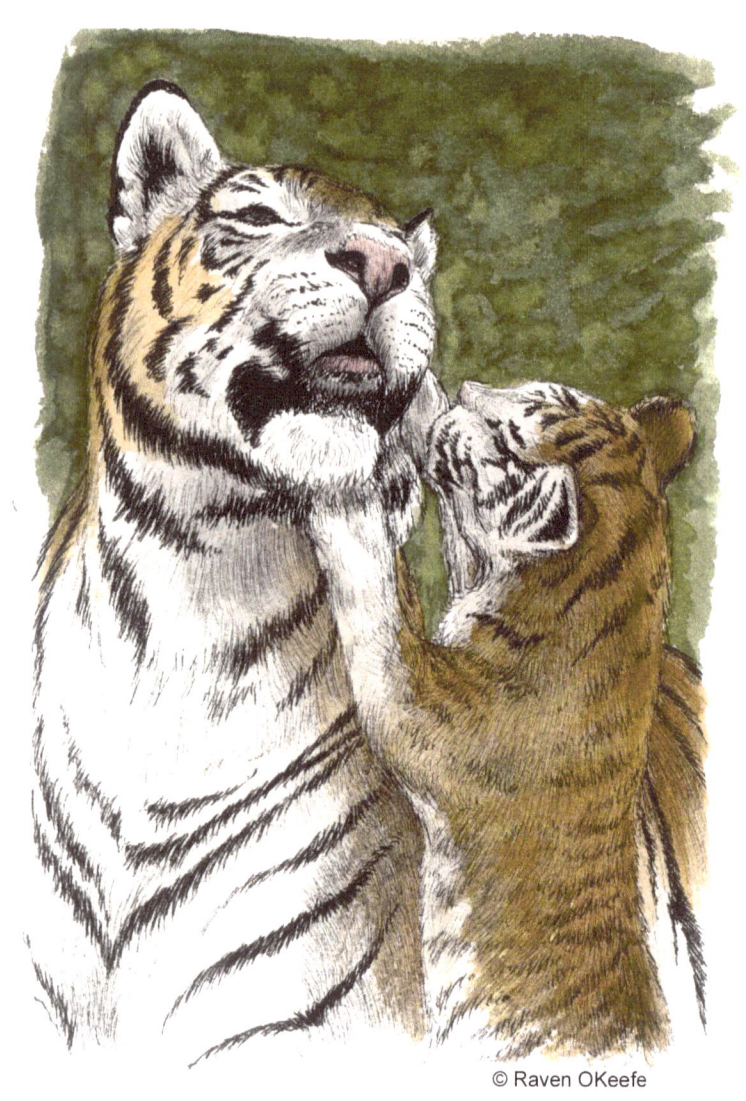

Hey Mom? Mom?

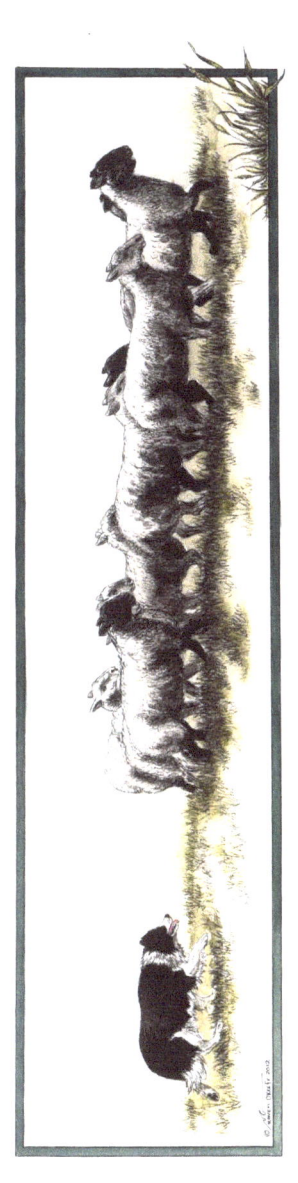
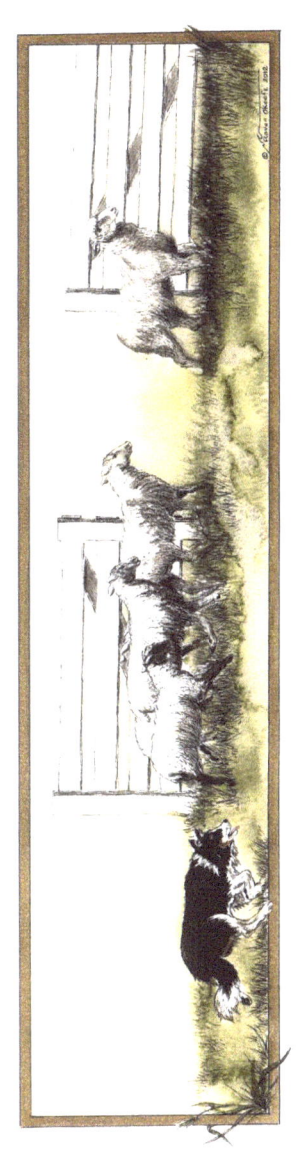

Working for a living

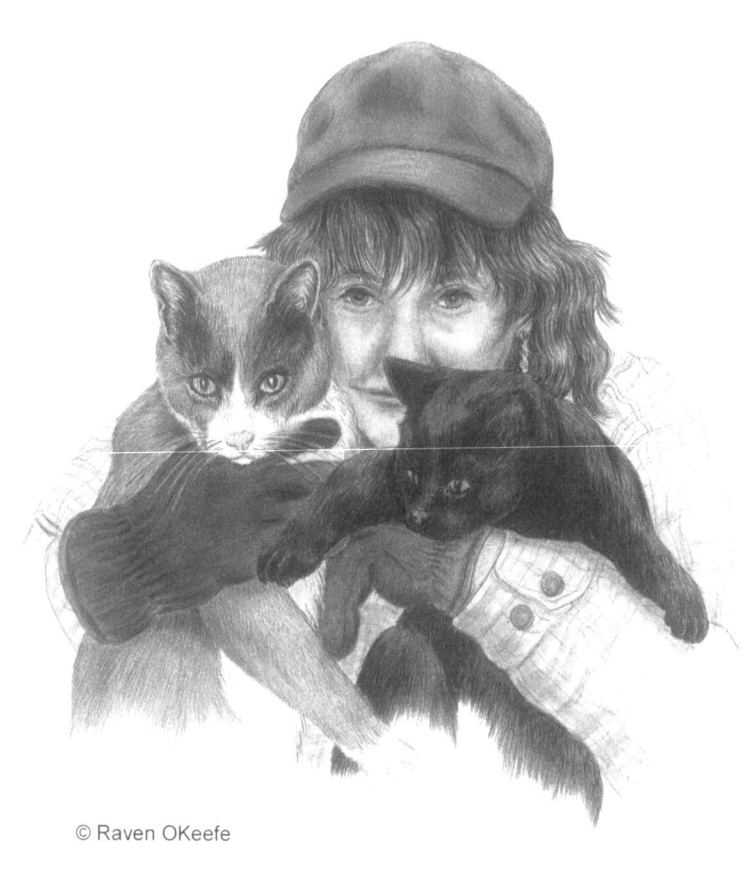
© Raven OKeefe

Jinx, Jake & Me

"How hard could it be to choose 55 favorites pieces from the art I've done in my life so far? When my good friends Randy and Jean-Marc Lofficier suggested this book, I was delighted and thought it would be a snap. Not so! I have created literally many hundreds of commissioned portraits over the years, along with other types of art, and it was astonishing, challenging, and slightly scary to look through my files to choose the ones you see in this book. It was also sad to realize how many I've done but have no record of them, thanks to various computer crashes and my own failure to photograph or scan much early work."

<p align="center">Raven</p>

www.ingramcontent.com/pod-product-compliance
Lightning Source LLC
Chambersburg PA
CBHW041107180526
45172CB00001B/150